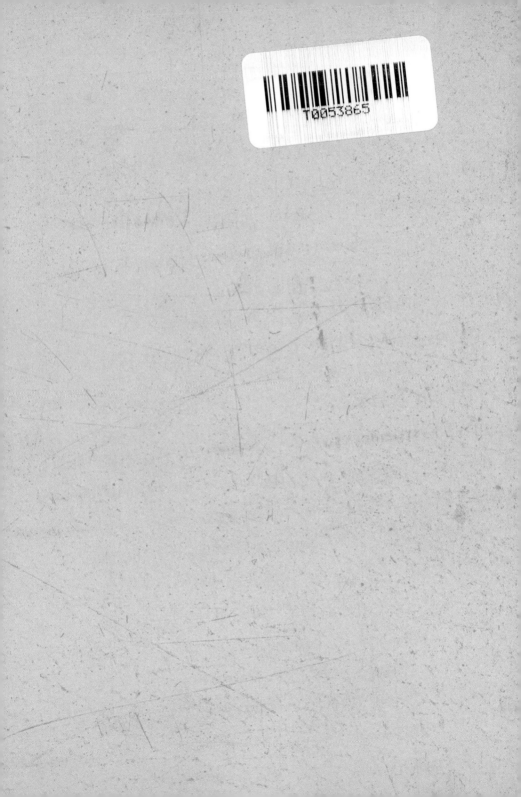

ANGELOLOGY

An Illustrated Encyclopedia of Celestial Superheroes!

Discover the Powers, the Names,
and the Virtues of 224 Angels

Text by
Angemì Rabiolo

Illustrations by
Iris Biasio

Red Wheel

CONTENTS

HISTORY, LEGEND, RELIGION

ARCHANGELS

HISTORY, LEGEND, RELIGION

INTRODUCTION

Once there were angels; now there are superheroes. We like the idea that we are not alone and that we can turn to someone stronger than we are in moments of need. More importantly, humans have always asked themselves about the presence of another dimension and they have wondered how to communicate with it, which is why the figure of the angel, a messenger and mediator with the divine, exists in many cultures.

The central theme of this book is the idea of completing a path—a path that begins with God and leads to humans through the hierarchy of the angels. Those steps can also be reversed, using the spiritual evolution of the individual that is advanced and elevated through reflection on the existential questions that all humans ask themselves. At the same time, a description of the angelic choirs will help reconstruct the chain of divine emanation that transforms the original order into thought and ultimately into material expression, thus allowing the created element to assume its own identity and characteristics.

METHODOLOGICAL NOTE

The intent of the interpretation in this book is to arouse curiosity and stimulate new reflections without presuming to include everything ever written about angels. The discussion is, in part, a personal re-elaboration of the sources, and it aims to accompany readers on a spiritual journey to discover the power of angels.

RESOURCE NOTE

BIBLE: A sacred text for Jews and Christians, the Bible is made up of seventy-two books, written at different times and in different languages. It is divided into the Old Testament, acknowledged by both religions, and the New Testament, the sacred book for Christians that narrates the life of Jesus.

THE BOOK OF ENOCH: An apocryphal text written in the first century BC, made up of five books, the best known of which is the Book of Watchers, which contains the first thirty-six chapters. They tell the story of the two hundred angels that were sent to Earth by the Lord to help man, but the angels were corrupted by the beauty of the world and entered into unions with human women, disobeying the orders of God, who then sent Michael, Gabriel, Uriel, and Suriel to punish them. In addition to the Book of Enoch, attributed to Enoch the Ethiopian, there are also *The Book of the Secrets of Enoch*, attributed to Slavic Enoch, and the *Hebrew Apocalypse of Enoch*, written on a more ancient basis around the 5th or 6th century by Rabbi Ishmael ben Elisha.

THE BOOK OF THE SECRETS OF ENOCH: An apocryphal text of the Old Testament that dates to the 1st century, attributed to Slavic Enoch. It narrates Enoch's journey through the seven heavens and his arrival into the presence of God, where he becomes the archangel Metatron.

SOLOMON'S TESTAMENT: By an unknown author but attributed to King Solomon, this 1st-century apocryphal text from the Old Testament tells the story of King Solomon, who used a magic ring—given to him as a gift from Michael—to make demons build his temple.

THE GOSPEL OF BARTHOLOMEW: An apocryphal text in the New Testament, attributed to the apostle Bartholomew. Its original nucleus dates to the 3rd and 4th centuries. Many translations exist, the oldest of which is in Greek, conserved in two manuscripts, one in Vienna and the other in Jerusalem.

THE KORAN: The sacred text of Islam, it contains the message revealed by God to the prophet Mohammed around AD 600.

THE ANGELS, MESSENGERS AND EMANATION OF THE DIVINE, AND THEIR NUMBERS

The angels, messengers of the divine and guardians of humankind, are a powerful and, in some ways, mysterious presence in monotheistic religions. Similar creatures already existed in the polytheistic religions that preceded Hebrew culture (Phoenician, Persian, Egyptian, Assyrian-Babylonian, and Greek). Then, they represented natural phenomena and protected human beings; but it was with the great monotheistic religions that the presence of angels became necessary and that their number became better defined. Their role was to mediate between the sphere of the divine, distant and unreachable, and the sphere of humankind. Because of their enormous importance and their ancient origins, many theories about their numbers have been proposed throughout the millennia. The Hebrew Kabbalah indicates the existence of seventy-two angels, whose names are found in the ancient biblical Tetragrammaton used to name God. Their names are formed by grouping letters three by three from three verses of Exodus (Exod. 14:19-21), whereas all of the 216 letters together make the true name of God. Despite the fact that Catholics recognize only three archangels, Michael, Gabriel, and Raphael, this verse is found in Revelation: "Then I looked and heard the voice of many angels, numbering thousands upon thousands, and ten thousand times ten thousand" (Rev. 5:11), which seems to suggest an infinite and incalculable number of angels. The Koran recognizes only two archangels, Michael and Gabriel, the inspirers of the sacred book of Islam, and a few other angels associated with Judgment Day or death. According to other apocrypha and other popular esoteric traditions, there are seven angels that hold up the world, the Planetary Angels, who in turn govern the twelve Zodiac Angels and the twenty-eight angels of the lunar cycle.

THE HIERARCHIES AND NAMES OF THE ANGELS

Seraphim, Cherubim, or Thrones? Between the 5th and 6th centuries AD, Pseudo-Dionysius the Areopagite systematized the classification of angels both to explain how the knowledge of all things and the creation of the world descended from God and to show which angels were closest to humans.

According to his outline, there are three hierarchies or spheres, each of which has three orders or angelic choirs. The first sphere is made of the spirits closest to God and includes the orders of Seraphim, Cherubim, and Thrones. In ancient times, each order was associated with the orbit of a planet. From it originated mysterious harmony called the music of the spheres, or *musica universalis,* which expressed the ordering principle of the world.

Going from the divine toward the human, the first order of angels is the Seraphim, who are in the Empyrean Heaven, closest to God. Here they burn with love for God and they radiate with his light, but they cannot look directly at him, which means that not even they can fully grasp the creating spirit. They have six wings: two to cover their face, two on their feet, and two with which to fly.

While the Seraphim burn with love, the Cherubim sit beyond the throne of God, in the starry night, from where they contemplate the spirit. They take the intuitions of the Seraphim and transform them into thoughts. In ancient times they were thought to be the guardians of Eden and, before being depicted as likeable *putti* in the Baroque period, they were described as having four wings and four faces, one of a human, one of an ox, one of a lion, and one of an eagle.

The Thrones sit close to the throne of God and are colorful and changeable in form. They take the thoughts of the Cherubim and transform them into actions. They are depicted as intersecting wheels with countless eyes.

The second hierarchy includes the Dominions, the Virtues, and the Powers. The angels of the Dominions carry a scepter and receive their tasks from the Seraphim, the Cherubim, or directly from God. They regulate the activities of the lower-ranking angels. Their order is found in the middle between Heaven and Earth. The Virtues, also called the Fortitudes, are fighting spirits who gather divine messages and preside over the great changes in history, representing all that evolves on Earth. The Powers are colorful and ethereal. They represent the knowledge of diverse disciplines and are the keepers of history.

The last hierarchy is composed of Principalities, Archangels, and Angels. The Principalities inspire new ideas and inventions, and they oversee nations, politics, and commerce.

The Archangels are great counselors and the defenders of the people, which distinguish them from the Angels who make up the last angelic choir, whose task it is to watch over and inspire the conscience of individuals. Often, the angels of the Archangel choir are confused with the archangels who guide angels of the other angelic choirs, because the same term is used to indicate both.

THE GENDER OF THE ANGELS

Angels are pure spirit, a direct emanation from God, and possess a fragment of divinity; but like a mismatched puzzle, the sum of their parts produces not a total divine essence, but always and only a part of one. Being spirits, they have no body and no gender.

Saint Thomas Aquinas wrote that angels have a pure form that can take on any semblance. When they come to Earth, they choose to appear as humans to avoid frightening us. They know the limits of matter, which relies on the senses to reach consciousness.

In Western art, angels are depicted as men due to the influence of patriarchal culture throughout history, but a closer look at their faces reveals feminine features. The idea was to use the feminine to depict divine beauty and to underline the double nature of the Spirit, who embodies both the masculine and the feminine.

This interpretation is supported by a few Bible passages, including one in which two Cherubim angels were guarding Eden (Gen. 3:22), that state that angels always walk in couples, to represent both sides of creation. Just as in many cultures and traditions, our world is the result of a continuous tension between good and evil and between opposites that depend on each other and that interact constantly. Above them there is only Unity, abstract and divine in substance, which surpasses and transcends all inner divisions.

WAR IN PARADISE

"Never! I will not serve!" was humanity's first cry of rebellion. It was Lucifer speaking, the angel who most resembled God, perfect in his dazzling beauty. He was not only prohibited from looking upon the face of God, like the other Seraphim angels, but he was also insulted when God preferred a woman to carry his son and act as intermediary with humankind. Lucifer believed he should have been chosen, not a human made of flesh and blood, worthless with respect to the pure spirit of his angelic nature.

In his moment of rebellion, for the first time, Lucifer was not looking upon the divine; he was looking at himself and his desires, which he felt were being crushed by God's decision. As he reflected on this new condition that placed individuality above the will of God, he heard Michael, his brotherly friend, asking him in a taunting voice: "Who is like God?" It was the end of the sacred couple of the two angels and a declaration of war.

The fratricidal battle that broke out threw the heavens into turmoil. Light must dominate the darkness, at least in heaven, and the dragon must burn. Lucifer and his followers were not able to counter the wrath of justice, and they fell like lightning bolts, exiled from the light forever. Lucifer knew that punishment was inevitable, but he let his fury, like that of a betrayed lover, wash over him and dominate him. When Lucifer fell, Michael was promoted to head of the celestial militia. The war in Paradise was the beginning of the division of the forces of good and evil, each of which had its own army.

THE WATCHER ANGELS

Even angels make mistakes sometimes. According to the Book of Watchers, the disobedience of some angels led to man's ability to cultivate the land and work metals. God sent two hundred angels to Earth, later known as the *Grigori,* to help humans and watch over them; but as soon as they arrived, they were overtaken by their desires for worldly things, and they "took unto themselves wives, and each chose for himself one, and they began to go in unto them and to defile themselves with them, and they taught them charms and enchantments, and the cutting of roots, and made them acquainted with plants. And they became pregnant, and they bore great giants, whose height was three thousand ells" (Book of Enoch, Book of Watchers 7:1-2). God saw the corruption that the rebel angels had visited upon the Earth and decided to send the angels Michael, Gabriel, Uriel, and Suriel to punish them. He ordered Michael to act against Samyaza, the head of the fallen angels, and against all the others. "And when their sons have slain one another, and they have seen the destruction of their beloved ones, bind them fast for seventy generations in the valleys of the earth, till the day of their judgment and of their consummation, till the judgment that is for ever and ever is consummated. And destroy all the spirits of the reprobate and the children of the Watchers, because they have wronged mankind" (Book of Enoch, Book of Watchers 10:11-15). The Watcher Angels are still there, under the hills, fallen from the heavens to the center of the Earth.

ANGELS OF THE MOON AND APOCRYPHAL ANGELS

According to esoteric astrology, and later the Kabbalah, it is on the moon that Gabriel concentrates the cosmic, divine energies to be delivered to humans. He gathers the messages from the upper planes of the heavens and divides them among his twenty-eight angels, each of whom represent a spiritual specialty or quality, who dispense the messages and thereby modulate the moon's cycles.

The appointed angels use their affinity with humans to instill in their souls gift-thoughts that can be transformed into experience. Subsequently, the results of the actions generated by the original messages are brought back to the Moon and from there sorted and sent back to the higher angelic orders.

In the apocryphal text of the Testament of Solomon, we find the Healing Angels, angels who use magic to heal people, a concept that goes against modern Catholic beliefs that do not recognize magic.

Using the ancient association between angels and planets, the Planetary and Zodiac angels regulate the movements of the stars and planets, which in turn influence the Earth. The association with the stars is as old as the association of the angels with natural phenomena. It answered the need for an explanation for some natural phenomena before the dissemination of scientific knowledge.

GUARDIAN ANGELS

Depending on our path of spiritual evolution, each of us can have a guardian angel during our lifetime. At birth, we are often protected by the spirit of a deceased loved one, and we may be protected by the patron saint we are named for or on whose feast day we were born. If we have a problem, we can pray that a particular angel help us find a solution.

In fact, you can make an outline of the angels from the nearest to the farthest, starting with your guardian angel, the incarnation of the deceased, and ending with your Zodiac and Planetary angels. According to the Kabbalah, the angels of the biblical Tetragrammaton are also guardian angels linked to specific days of the calendar. In fact, each of the seventy-two angels brings a gift to children born during the five or six days that that angel governs, but even those who were not born on those days can pray to that angel to receive the benefits of their gifts or angelic powers. The days associated with each angel correspond to the degrees of the Zodiac, counted starting from the zero degree of the sign of Aries. The angel resides in that space and from there exercises influence on the lives of people born on those days.

ARCHANGELS

Spiritual evolution happens through the questions that we all ask ourselves. Who am I? Where did I come from? What is love? Why does pain exist? What is beauty? The answers to these questions determine the spiritual progress of each of us, the achievement of a higher level of awareness and nearness to the divine.

The thread on the following pages, which begins with existential questions, describes the principal archangels of Hebrew, Catholic, and Islamic traditions. We will discuss eleven of them, nine of whom preside over a choir, according to the Hebrew Kabbalah. They include the seven archangels of ancient Catholic tradition (which now recognizes only Michael, Gabriel, and Raphael, the only ones who introduced themselves by name in the Gospel of Luke) and the two who are recognized by the Koran: Michael and Gabriel, the inspirers of the sacred book of Islam. In addition to these are Sandalphon, the archangel who presides over the Earth's energy sphere, and Uriel, an ancient archangel eliminated by Catholic doctrine.

Why are archangels considered so important? Even though the angels believed to be closest to God are those of the first sphere, major religions traditionally dedicate more space to the archangels, meaning those angels that belong to the eighth choir as well as those that are "superior angels," as their name indicates. In fact, an archangel is the angel at the head of each angelic choir and the angel who has had the task of coordinating and guiding the other angels on specific occasions.

The angels of the first sphere, the Seraphim, Cherubim, and Thrones, are to be considered entities of pure energy whose constitution makes it impossible for them to interact directly with humans or to approach the Earth. There is a precise order in the emanation of divine energy and messages through the hierarchies, and the angels of the first sphere communicate to humans through angels of the lower spheres. That is why archangels are presented in order of emanation, from those closest to God to those closest to the Earth. The pages can also be read in

the reverse order, beginning with the angels closest to humans. Doing so will reveal a path of spiritual evolution, achieved through the fundamental questions of humans that raise their consciousness of the earthly world and the divine. All archangels have a precise task that influences the existence of every human, and their incessant work permits humans to live their earthly life and to achieve spiritual fulfillment.

Symbol Legend

Powers

Classification in Islamic tradition

Classification in Catholic tradition

Classification in Hebrew tradition

Classification according to apocryphal texts and ancient astrological, theological, and theosophical traditions as well as esoteric traditions, including evocative magic, peasant culture, and mystery religions

Belonging to the list of guardian angels according to the Jewish-Catholic classification

⚡ **POWERS**

Enlightens the mind | Gives prophetic visions

METATRON

The Right Hand of God

THE MEANING OF HIS NAME: "Secretary of God," "The Lord's Personal Angel," "Little YHWH"

He mediates between good and evil and presides over knowledge of the divine

Archangel of the Seraphim choir

> Is it actually possible to believe what you cannot see? Is there a divine plan for the whole world and for each of us? At times we have a feeling, but it is a fleeting apparition sent by Metatron, from his place at God's side.

Metatron is the Archangel closest to God, his first expression and the ultimate order of truth before divinity. He receives his orders directly from God and then delivers them to all the other angels. There are not many traces of Metatron in the Bible, but he is spoken of in the Book of Enoch, which says he was the angel into whom the patriarch was transformed at the end of his journey to heaven.

He is the highest expression of the spirit. Without mediation, he embodies divine messages with the flaming love that keeps him anchored in the highest of the heavens, far from humans. Despite his privileged position, he cannot see the face of God; his relationship with the divine is based only on the faith and mystery it implies, far from the eyes of reason. Just as Metatron conducts celestial affairs in such a way that good prevails over evil, his twin Sandalphon governs the energy on Earth by regulating the elements.

In the same way that he cannot see God directly, he is seen by humans only in fleeting intuitions of the order that holds up the cosmos and its expressions. In rare moments, humans may have an epiphany and, without understanding it rationally, perceive the order to which they belong and within which the existence of every creature has its own reason for being. It is a vision that resembles a dream that dissolves and disappears, leaving only a sensation behind. It is up to each of us to decide whether or not to follow it and embark on a path of spirituality and knowledge that will elevate us and free us from material restraints.

Metatron enlightens the mind, revealing the goal of creation, thereby revealing the future. Individuals will then decide whether or not to aspire to the truth that has been announced and revealed to them. By giving them a vision of the future, Metatron gives humans the ability to be prophets and indicate the way for others to accomplish the plan in which good prevails over the forces of evil. With the characteristics of a self-fulfilling prophecy, this vision makes it possible to achieve goodness in the time and space of humankind.

Metatron's Cube

New Age trends associate Metatron, also known as the Archangel of Life, with the sacred geometrical figure Metatron's Cube, in which the map of creation and of all things that exist and are possible in nature are said to be visible.

The cube is made of thirteen circles and seventy-eight straight lines. The curved lines represent the feminine, and the straight lines represent the masculine, two opposites that express all things communicated to Metatron by God and by Metatron to all of the other energies in the Universe. As they intersect, the lines create the five Platonic solids—tetrahedron, cube, octahedron, dodecahedron, and icosahedron—that represent the elements of Fire, Water, Air, Earth, and the Heavens. These figures intersect and reside together within the cube as a symbol of totality and of the variety of things that can descend from a single principle.

A sixth mystical shape is present in the cube, a sort of three-dimensional Star of David called Merkabah, that symbolizes the celestial chariot that is believed to carry the soul to superior levels of consciousness and knowledge through the transcendent union of body, spirit, and light.

Today, Metatron's Cube is used to explain the (scientifically unproven) theory of vibration, according to which all things in nature carry energy vibrations with which the human soul can be harmonized, like a diapason, thus dissolving the energy imbalances that cause its problems.

⚡ POWERS

Enlightens the spiritual path | Instills wisdom

RAZIEL

The Archangel of Love

THE MEANING OF HIS NAME: "God's Secret"

He reawakens the mind and breaks the chains of habit

Archangel of the choir of Cherubim

| **What is love? What purpose does it serve? Raziel unveils the mystery. Love is what upholds the Universe.**

According to Hebrew mythology, Raziel is the archangel who holds all the knowledge of the world and illuminates the mind, in order that humans can know the most intimate secrets of creation and the true reason for which all things were created: an act of pure love.

This is the role of Raziel, the archangel who reawakens the conscience of those who look to the divine to find the meaning of their lives. He transforms the spiritual order into thought—not that of pure rationality, but that of intuition, a kind of knowledge different from that of inductive and deductive reasoning. The illumination can come suddenly, in fact, through associations that surpass the filter of logic, but that leave a strong-enough impression on the human soul to produce change.

Raziel lights up not only the human mind, but also something deeper: the conscience and the consciousness that help us distinguish good from evil in our own souls. Initially, humans separate good from evil in the world that surrounds them; but in time, reawakened humans turn their eyes inward to identify what anchors their spirits in the negativity that lives within them. This awareness of self and the world creates wisdom.

By revealing the ultimate reason that the world and humans were created, Raziel also shows us the difference that exists between divine and carnal love. The love of God is completely free, a gift given to humanity with no expectations of anything in return. Recognizing this spark of universal love in every worldly expression leads those who have embarked on a spiritual path to look at creation as a manifestation of the divine Unity that supersedes the contradictions and differences present in reality. As they recognize themselves as part of this mechanism, reawakened humans begin to feel the desire to be part of this universal love and to use it as a tool with which to reproduce the same in the earthly world. Thanks to the love revealed by Raziel, man can overcome his dark tendencies and can go from being the created to being a creator.

The Love That Moves All Things

"Here force failed my high fantasy; but my desire and will were moved already like a wheel revolving uniformly, by the Love that moves the sun and the other stars." These final verses in Dante's *Divine Comedy* close the twenty-third canto of the *Paradiso*. They describe the amazement of the human mind that, when reawakened, becomes part of the mystery of life and of the Universe and finally perceives the structure and the order that moves All Things. Dante's writing falters in front of this vision. His journey has elevated him; from unawareness he has passed through all the facets and degradations produced by earthly desires and continued his journey, detached from the material, in search of the answers to the questions that all men of all times have asked themselves. Who am I? What is the world? Does something other than what I can see exist? If it does, what is it?

As they look upon the unfolding of the mystery of life, truth, and the light, humans are left speechless and can only contemplate the greatness of the One that embodies all things, that transcends its opposite while holding it within, and that can be seen as a spark in all things ever created.

According to many religious traditions, the only force that could have brought the visible Universe into being is that of love. In the middle of the Universe are humans, who, even before the divine, retain their conscience and free will and the power to manage their own freedom. It can only be a higher will that created all things, expecting nothing in return. Humans have just to embark on their path, if they so desire, moved by an impulse that they perceive in their flesh, an impulse that calls for their reason but that can be grasped only with intuition.

⚡ POWERS

Helps to understand existence and to actualize ideas

BINAEL

The Writer of the Code of Life

THE MEANING OF HIS NAME: "Vision of God," "Contemplation of God"

He makes the right thing happen at the right time, governing time and space

Archangel of the choir of Thrones

Planetary Angel associated with Saturn

Why does one thing happen, rather than another? Why does it happen at a given time rather than another? Do cosmic laws that determine what we see exist? Binael is the Hebrew archangel depicted with a pen in his hand, always ready to take note of what is happening on Earth and in the souls of humans. He is the keeper of the great book of time and is the master of the cosmic order, whose laws he wrote.

He is the philosopher of creation, the writer of the rules of the Universe that humans are still trying to grasp and understand, as they search its existence and the essence of things for the common element that has allowed them

to evolve in space and time. Binael takes divine creative force and makes it comprehensible; he is the archangel that explains and helps understand the beauty of the code and of the mathematical order that determines the arrangement and proportion of the elements in the Universe.

He gives the gift of knowledge to humans who seek it, enlightening them and awakening in them the need to investigate and understand. In doing so, Binael sacrifices himself and accepts his role as regulator, molding the message so that humans can understand it and carry it within, despite their inability to grasp it entirely. Binael's sacrifice also lies in his responsibility to choose what can be conveyed and what must be kept secret from the rational mind.

In the same way, humans who seek knowledge of the world sacrifice themselves, abandoning all that would keep them from a life of study. They are motivated by a fleeting vision of the order of things; to follow it and develop it, they become deeply involved in study, in a forest full of questions where it is easy to make mistakes and get lost.

When humans are faced with the potentially infinite nature of their search—where, in addition to the atom, they will find the components of the atom and then the elements that make up each of those, like small boxes, one inside the other—they could get lost. They often fail to understand that the meaning of knowledge is in the search itself; the answer is in the code, and all those who question themselves will find an answer of their own.

The Secret of the Wheel

Binael is the archangel of the choir of Thrones, who in ancient times were depicted as wheels with chains of eyes. Thrones don't only try to represent the vision that they receive from God; they also try to arrange things and facts in space and time in such a way as to help humans understand and learn lessons from their life experiences. In helping humans recognize their own destiny while at the same time helping them to better understand divine justice, they aid in achieving the plan that God has for every individual.

The linked living wheels symbolize the continuous search for meaning, which is destined to find a new beginning each time it reaches the end. It creates an incessant movement in which it seems stationary as it revolves upon itself; but in reality, the constant search changes time and space. Those who imagine that they are motionless as they search for the meaning of the world and of its existence are actually moving and evolving through questions and answers. They move from one circle to another, and from one wheel to another, like a spiral uncoiling in the mystery of time—which, though it may seem circular, can be arranged on a straight line as well.

Once again, the search for the essence and the repeated dissolution of the object—and what lies within it—ultimately leads to an overall vision, from the one to the all. Thus, the more humans look for the meaning of their lives, the more they find themselves at one with the existence of other humans and with the world, just like a series of interconnected wheels.

⚡ POWERS

Gives the gift of prosperity | Helps personal achievement |
Reestablishes psychophysical balance

HESEDIEL

The Archangel of Desire and Benevolence

THE MEANING OF HIS NAME: "The Justice of God"

He brings balance to the soul

✝ ✡ **Archangel of the choir of the Dominions**

◭ **Planetary Angel associated with Jupiter**

> **What is happiness? A collection of fleeting moments that accentuate existence and reawaken the desire for a life beyond logic and feelings.**

Hesediel helps us by prodding our souls, stimulating our search for that which gratifies us spiritually, and reawakens in us the desire for life and knowledge. On one hand he tests us, and on the other he is always ready to protect us, just as he did with Isaac, who was about to be sacrificed by Abraham as an extreme act of devotion to God.

Often depicted with a scepter in his hand and a crown on his head, he is the son of divine Reason, which he warms with the power of Sentiment. The heart does not dominate; it governs the indefinite space where it is possible for reason and sentiment to meet. In fact, humans searching for ultimate

balance must look inside and outside themselves for a place where they can rest and recalibrate their energies before the next battle.

As we walk through the world, we sometimes have the good fortune to experience happiness. All of us have small jars of perfect moments on the shelves of our existence; we know they are there, and we know how they smell and how they taste. As time goes by, the taste of that happiness becomes fainter, so we set off again, looking for its vague scent so we can bottle it once more—a new drop of perfect reality that can change our own existence and that of others, who in turn are chasing their own desire for happiness.

Hesediel never abandons humans in their difficult search, but he prods the soul of those who have given up on finding happiness. This archangel indicates the way to a full life; he helps to remember the goals we have reached, and he encourages us to search for happiness—which, through the fulfillment of worldly aspirations, motivates us to search for other, more spiritual ones. It becomes a search within a search. The well-being that stems from a feeling of satisfaction incites us on our path, but it also creates our inclination toward another desire to fulfill.

Through their desires, humans free themselves little by little and complete themselves in their essence; they find a balance between earthly enjoyment and the understanding of the divine expressed in the world.

Harmony with Oneself and with Others

Mahatma Gandhi taught us, "Happiness is when what you think, what you say, and what you do are in harmony with one another." It is easy to confuse happiness with material wealth, but this is not the type of happiness that will make you feel suddenly, and for just a moment, in harmony with the world, trustful of humanity and the future. That sense of fulfillment is easier to achieve when you look at the world through the eyes of a child who finds happiness in the small things. When you experience this well-being, the joy of the present makes you forget the rest.

But how can individual happiness be useful for others? Is there a kind of happiness that is not egoistic? If everything was preordained and God created us to be happy only in the good, how do you explain those who are ready to walk over others to achieve their own happiness?

Desire can confuse the soul, and the will to conquer happiness for yourself can have a disastrous effect on others as they follow their own quest for the same. In this case, reason has to take over and dominate the feeling of desire. Rationality tempers the passion for accumulating things and helps distinguish between happiness that is full and happiness that is empty. The latter lives and dies in an instant, but full happiness resonates in our souls. We remember it, and it becomes a step toward fulfillment. And even if it is linked to the satisfaction of earthly desires, it shines with something else: a kind of happiness that makes you feel good even after the feeling has passed, an overflowing gratuitous happiness that improves us and opens the way for others to improve themselves, because those who find inner harmony will eventually look for it in others.

⚡ POWERS

Supports the will and uses it for good |
Brings about the good outcome of plans

CAMAEL

The Warrior of Karma

THE MEANING OF HIS NAME: "The Rigor of God," "He Who Sees God"

He uses evil to achieve good

Archangel of the choir of the Powers

Planetary Angel associated with Mars

Why do we suffer? Why do we feel inadequate, imperfect, and dissatisfied? Camael accompanies us through our pain and fatigue, holding out his hand and lighting our spiritual path just as he did with Adam and Eve: he banished them from Eden but did not leave them at the mercy of the events and of their desperation.

Camael brings the curse of original sin to life. Humans cannot enjoy existential fulfillment without paying the price of fatigue and suffering. Without this painful motivation, humans would achieve well-being and happiness without earning them and would have no reason to improve their condition. Total well-being may seem to be the condition in which we would all like to live; but in reality such a condition would mean there were no more choices

and the world would come to a halt. No one would have the impulse to create something else, and people would no longer try to change the condition in which they exist, since they would have already obtained the maximum.

This is not the destiny of humans, who were not made to be the object of the Universe but rather to be, themselves, creators. Humans are a part of a divine plan, but they cannot see the plan, except for fleeting visions of what might be, if they are willing to work hard enough for it. Humans struggle with the desire to know and to possess all things—and, as they search for the light with an infinite hunger for knowledge and happiness, they often find themselves chasing shadows.

Only through error will they be able to curtail their desire: they must recognize their imperfect substance as humans on the one hand and, on the other, find the tools to begin on their path again. This is the journey on which the destiny of humans takes shape, and the archangel Camael keeps track of all the experiences of all humans. He is the counterpart to the temptations of Lucifer, but his enlightenment and help can only be had through the ordeal of experiencing evil. In this sense, it is the existence of the forces of evil that makes it possible to achieve good, just as the existence of darkness allows us to define the light.

The winner will be known only in the end. In the meantime, however, all humans will have left a trace of their existence, and each will decide what to leave.

Banishment from the Garden of Eden

"The ground is cursed because of you. You will eat from it by means of painful labor all the days of your life. It will produce thorns and thistles for you, and you will eat the plants of the field. By the sweat of your brow, you will eat your food until you return to the ground, since from it you were taken; for dust you are and to dust you will return" (Gen. 3:14-19). This was the punishment for eating from the tree of knowledge of good and evil. Adam and Eve were allowed to touch it but not to eat its fruit, because total knowledge and satisfaction of every need would have impeded the evolution of humanity. God does not oppose the desire to know the world and the divine, and such temptation has existed since the beginning of time. Neither the serpent nor Lucifer himself could exist if not as part of the divine plan. The banishment from the Garden of Eden was not punishment for an error committed, but rather for an act of arrogance, the desire to elude human destiny.

Humans can, in fact, decide to dedicate themselves to good as well as to evil and are often attracted by both. The inclinations both toward the divine and toward the malevolent that reside in all humans are in a constant battle between opposites, a battle that is sometimes won by one force and sometimes by the other. Humans are free to choose and may even choose to devote their existence to darkness, but they can always seek the help of the divine through prayer.

Ultimately humans make their own decisions and must make their peace with their own errors and inadequacies, and they themselves must pay the consequences for those decisions.

⚡ POWERS

Cures ills | Protects the young, spouses,
and travelers | Nurtures and purifies desires |
Strengthens the will

RAPHAEL

The Healing Archangel

THE MEANING OF HIS NAME: "Remedy of God," "God Heals"

He cures physical, mental, and spiritual maladies

Archangel of the choir of the Virtues

Planetary Angel associated with Mercury; Upholder of the world and Vigilant Archangel

Is there someone who can cure us spiritually? When humans suffer and cry out in pain to the heavens and when they think they are alone and at their end, Raphael the Healing Archangel intervenes.

The third archangel to be called specifically by name in the Bible, his healing ability is narrated in a biblical episode by Tobias. According to the story, Raphael descended to Earth in human form and with a human name in order to accompany and protect Tobias, who had been sent to another city by his blind, aging father to collect a debt. When they got to the Tigris River, Tobias caught a fish for dinner; as he was cleaning it, Azarias (Raphael's

human name) asked him to set aside the fish's heart, liver, and bile. The request surprised Tobias, who asked why he should do such a thing. Raphael answered that the bile would cure blindness, and the heart and liver would drive the devil out of the heart of Sara, the woman Tobias was to marry. She had already been married seven times, but she had never been able to live as a wife because the devil had killed all her husbands before their first night of marriage. After the wedding, Tobias used the fish's heart and liver as Raphael had instructed him; his wife was freed from the devil, and he survived. When he got back home, he used the bile on his father, who then regained his eyesight.

Raphael is the angel to turn to in times of suffering. He embodies both reason and sentiment, which is why he is often associated with the heart that beats according to physical laws but is also known as the place where our emotions reside. Raphael is the doctor who listens to our hearts and souls and takes care of them, instilling strength and supporting the will necessary for humans to endure the cure.

The Archangel and the Holy Little Girl

D uring one of his encounters with Anna Maria Gallo, who would come to be known as Mary Frances of the Five Wounds, patron saint of the Spanish Quarter in Naples, Raphael told her, "I have been sent to cure your afflictions." She was born in Naples in 1715 and lived a difficult childhood with a terribly abusive father. Her only distraction was prayer and, in fact, people in her neighborhood called her the "little saint." When she was sixteen, she asked her father for permission to take her vows as a nun, but he had already promised her hand in matrimony, so it was only after the intercession of a priest that she was allowed to begin her life as a nun. Anna Maria took her vows as a Franciscan with the name of Mary Frances; but having fulfilled her wish did not make her life easier: quite the opposite. In addition to the work required by the order and the constant fasting, her life was made more difficult by the sores that afflicted her throughout the entire Lenten season. She refused rest as well as any kind of help, and she practiced self-flagellation. Under her clothes, she wore a hair shirt as she silently endured the constant attacks of the devil, who scorned her, calling her *"perrucchella,"* a nasty insult.

But despite the pain and sacrifice that every breath cost her, her faith continued to grow. Mary Frances could feel the archangel Raphael by her side. He helped her even in the little things; he cared for her sores and he fed her when she lacked the strength to feed herself. She spent her life sacrificing her body in order to uplift her spirit to a place where flesh cannot go, searching for that divine essence that is invisible to the eyes but not to the heart.

⚡ POWERS

Protects those who love | Brings harmony to couples | Inspires artists

HANIEL

Charmer of the Senses

THE MEANING OF HIS NAME: "Glory of God," "Grace of God"

He governs the five senses and encourages the love of beauty

Archangel
of the choir
of Principalities

Planetary Archangel
associated
with Venus

> **What is beauty? To look with wonder at the sea and read the story of the world in it, to allow yourself to be enchanted by your senses in order to fly high with your spirit. Haniel is the archangel of beauty. He protects artists, and, thanks to him, we can be amazed by the beauty that surrounds us and inspires new creations in us.**

Few people can perceive the harmony of the cosmos, and even fewer can translate that harmony into art to share with the rest of humanity. Beauty is like a glimpse into eternity that looks out over time. In the sudden instant when the soul is present, all senses align and can see as they have never seen before. Perhaps it is a bit like going back to being a child and being amazed by the wonderful greatness of the Universe.

For centuries, artists have tried to reproduce the thoughts that strike them. People have looked for the rules of beauty, a criterion that makes it duplicable and producible: symmetry, proportions, golden ratios, and dimensions—all to arrive at a different realization, one that reveals to us that sometimes the ugly is more beautiful than beauty. We fall more in love with imperfection than with its opposite, because we cannot dominate our senses; we can only educate them: but, ultimately, our reason and logic are overridden by that warm instinctive part of us as humans that refuses to be analyzed, deciphered, and understood.

Haniel governs our senses; he encourages us to love the beauty that makes humans want to possess all that they see as unique and irreplaceable in their existence. Knowledge is created through interest; the more our senses are gratified by affinity, the more we want to possess and penetrate the object of our love and its most intimate secrets, but this possessiveness can be selfish and destructive. When love is on a purely sensorial and material level, all humans kill what they love in a desperate attempt to preserve the idea of it that they have shaped in their minds, and to keep it for themselves for eternity. It is possible, however, to learn to love without destruction. You can love a flower that has been cut; but if you want to continue to enjoy a flower, you must respect its essence, which is a fragment of the larger beauty that pervades the cosmos. The challenge is to love that flower with your senses, using them to elevate your spirit; you can love it without cutting it from the plant.

The Non-Finite

The slaves writhe in an attempt to free themselves from the matter that crushes them and hides their shapes. Their mouth is nothing but a crude slash, but it seems as though they scream with their entire bodies to convey the desperation of a condition that knows no help or compassion. Their fate is sealed, and they know that they will never free themselves of the stone that imprisons them and become flesh and blood. They are the sculptures in Michelangelo's group, the *Prisoners*, the artist's attempt to express his ideas by tearing away the material to reach the true essence of beauty, but the sculptures remain imprisoned in the marble just as ideas are conditioned by the physical world. It is the destiny of humans to want, to yearn, and to be consumed by desire and to be unable to do anything other than try to reproduce an inspired supreme vision with the finite number of tools at their disposal. The result of the finished work will never be as beautiful as the inspired vision from above, from Elsewhere, a place where all the ideas are before they are thought of. From above to below, from the divine to the human, we proceed by subtracting, just as the statue frees itself from the stone. To reverse the process would mean proceeding through accumulation; but once again, in order to achieve spiritual elevation, we must subtract and strip away so we can begin again, from our senses, in order to free ourselves of them. The climb becomes more laborious as we go higher, clinging to the idea that generated the action, and even higher, from will to conscience and on to the knowledge of good and evil; never stopping, always pushing beyond to where man's bearings are no longer those of the individual but rather of humanity itself, and arriving finally at the divine. Looking down, finally, and finding ourselves bare in the essence of all things, we discover that there is no longer an above and below, an inside and an out, but only the communion of the cosmos to contemplate, a harmony we can listen to and sigh.

POWERS

Instills strength and courage | Protects the pure of heart

MICHAEL

The Prince of Warriors

THE MEANING OF HIS NAME: "He Who Is Like God," "Who Is Like God?"

He fights evil with a sword and armor

Archangel of the choir of the Archangels

One of the two angels who inspired the Koran

Planetary Angel associated with the Sun; Ruler and Watcher of the world

Who protects us from evil? When the going gets tough, the tough get going; and when battle is necessary, in Heaven or on Earth, the archangel Michael is the one to call.

He wears armor and holds a flaming sword tight in his fist in his relentless battle against evil. His goal is to dominate it rather than eliminate it, because he knows that evil must exist just as good must.

He is the superhero that humans and angels trust to reestablish peace and justice. He demonstrated his loyalty to God at the dawn of the epic

battle between good and evil, when the history of humanity began. In fact, Michael made a difficult decision when he had to raise his sword against his favorite brother, Lucifer.

While Lucifer wanted to be God, Michael decided to serve God, and his humility made him "equal to God." When the celestial battle exploded in all its violence, Michael the archangel used his sword to cut away the evil from what had been Unity, relegating Lucifer and his followers to Hell; and from that moment he became the overseer and the guardian of the separation of good from evil.

According to the Bible, Michael is present at both the beginning and the end of the world. He is the one who inspired John's vision of the Apocalypse, the one who sounded the trumpet that marked the beginning of the final battle of the Last Judgment, and the one who gave back to God what was left of the world.

His nature is not separable from battle, and his sword is always drawn, full of passion and faith. He is the strong warrior devoted to protecting the weak with his powers. His figure as the quintessential archangel is so strong that it is recognized by Christians, Jews, and Muslims alike.

He is not a warmonger. He uses his sword to maintain the fragile balance of the world, of humanity, and of the Afterlife. He brings about monumental changes and freedom from conflict, but the purpose of his actions is always to reestablish balance between opposing forces. He is the defender of human beings because, like them, he had to make the great decision between good and evil, between darkness and the light.

The Maiden of God

"Let all those who love me follow me," cried Joan of Arc. As she galloped away with her white banner, she felt the presence of the archangel Michael by her side. Behind her, soldiers lowered their heads as they entrusted their souls to God and their bodies to a young girl dressed like a knight, and aimed their swords at the English enemy.

In the war between France and England that began in 1337 and would come to be known as the Hundred Years' War, the Maid of Orleans fought to return the throne of France to its legitimate heir, Charles VII.

Joan of Arc was not born to fight; she was chosen. In 1425, when she was just thirteen years old, she had her first vision. She saw a flash and heard her name; it was the archangel Michael, telling her she must fight to win back the throne for the true king, the one who would become Charles VII on July 17, 1429. Joan took a vow of chastity that day and then departed, leaving everything behind. She could have come home once she had succeeded in her endeavor, but she decided to continue to fight for the reunification of France. She marched to Paris to recapture the city, but she failed and was deceived, captured, and sold to the English. In prison, she was accused of heresy because she dressed as a male. It seemed as though her Inquisition procedure would end with her abjuration; but a day later, Joan changed her mind and declared, "God informed me of His great sorrow for the treason that I had committed by signing the abjuration. To save my life, I betrayed Him; and in so doing, I damned myself!" With these words, she sealed her death sentence, and she was burned at the stake at just nineteen years old.

⚡ POWERS

Encourages renewal | Offers support during change |
Stimulates creativity

GABRIEL

God's Messenger

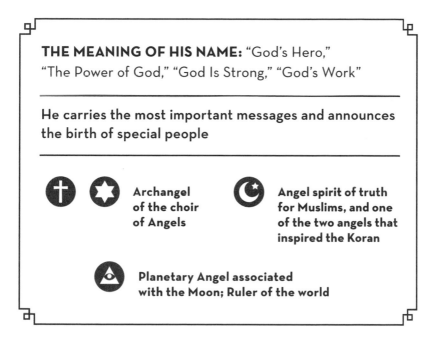

THE MEANING OF HIS NAME: "God's Hero," "The Power of God," "God Is Strong," "God's Work"

He carries the most important messages and announces the birth of special people

Archangel of the choir of Angels

Angel spirit of truth for Muslims, and one of the two angels that inspired the Koran

Planetary Angel associated with the Moon; Ruler of the world

How are divine messages carried to Earth? Gabriel is responsible for this task. He is the fastest; he moves at lightning speed, and he's the most reliable messenger of the angelic ranks.

Gabriel appears whenever the birth of an important person has to be announced. He announced to Abraham that, despite his advanced age, he would become a father and that the chosen people would be among his

descendants. He appeared to Zachary, the husband of Elizabeth, cousin of Maria, to say that he would have a son, John, who would later be known as John the Baptist. Six months after his visit to Zachary, Gabriel visited Mary.

"Hail, Mary, full of grace!" was how the archangel Gabriel, in the Gospel according to Luke, greeted the young betrothed, who looked at him, confused. She did not run away; she tried to understand what was happening as Gabriel continued to tell her that she would bear the son of God, that she would name him Jesus, and that the Reign of Jesus would be eternal.

Mary was speechless. She could probably foresee the great responsibility of having a child who was destined for great things and even greater tragedy. The mystery of Mary, the woman chosen to bear God, is the mystery of a mother who has always known she will not be able to protect her son from his destiny, but she accepts it and tries to stay near him.

Mary reflects on the words she has been told, and, other than the practical question that she asks Gabriel, "How is it possible? I do not know any man!" she offers no opposition; she accepts the miracle of divinity that, through her, will become flesh and blood. She agrees to carry, give birth to, and raise the man who embodies divine essence.

The moment Mary consents to become an instrument in God's plan is the moment that the New Testament is born. It distances itself from the idea of a vindictive God who lives in heaven. Instead, it presents the world with a God who is omnipotent but who needs the help of a messenger angel and a young girl, a God who decides to leave the perfection of the Spirit behind and contaminate his being with the material so that he can take all people by the hand and accompany them on their path of spiritual and human growth.

The Bridge of History

As soon as Gabriel set foot on Earth, the Divine Will became history. The announcement of the birth of Jesus was the year zero of our culture; and, although scholars agree about the historical accuracy of Jesus of Nazareth, the other stories in the Gospels are not intended to be historical chronicles. More important than a narration of facts is the evolution of the human soul and its journey, which is shaped by love and by the sacrifice that truly loving the freedom of others requires.

Three historical events in the life of Jesus are fundamental: his birth in Bethlehem during the reign of Herod; being baptized by his cousin John the Baptist; and his death by crucifixion on Mount Calvary. We know that Jesus of Nazareth was a preacher in the territory of what is now Palestine around the year AD 30, the same period in which Pontius Pilate was a Roman prefect in the province of Judea. After his baptism, Jesus retreated to the desert for forty days, and, on his return, he chose twelve disciples and began his activity as a preacher.

Some dates coincide; but because of the years between Jesus's death and the writing of the first Gospels, elements from other cultures were added to the story, and they intertwined to create a new text, the New Testament, which still today captures our attention on a variety of levels. The New Testament became the bridge between the spiritual and the material, between the old and the new, and between that which we can see with our eyes and that which remains forever invisible to our senses.

⚡ POWERS

Revives the soul | Facilitates spiritual harmony

SANDALPHON

Prince of the Elements

THE MEANING OF HIS NAME: "Brother." He is thought to be Metatron's twin

He governs the elements

✡ **Archangel Prince of prayer**

> **Who or what governs the elements and natural phenomena? The archangel Sandalphon governs the earth just as Metatron governs the sky. He listens to our prayers, the means through which we ask for divine intervention.**

Sandalphon does not preside over an angelic choir; but without him, the world would fall into chaos. For Jews, he is the archangel Prince of Prayer because every day, he delivers the prayers addressed to God. He collects them and weaves them into a crown that he places on the head of the Lord.

His name, which means "brother," identifies him as the twin of the archangel Metatron, the head of the Seraphim; but despite being related, Sandalphon does not belong to the Seraphim choir, according to sources of major religions. According to other sources, Sandalphon and Metatron

revealed themselves in history as the prophets Elijah and Enoch respectively; and upon their death they returned to heaven to dispense the energy emanated from higher spheres to humans.

Sandalphon represents the power of renewal of the Earth and the resilience of humans, in whom he instills the courage and the energy needed to be reborn and to change thoughts and habits in order to reach a higher level of self-awareness.

Just as in physics, where energy is neither created nor destroyed but is transformed, Sandalphon regulates the charge of cosmic energy that comes from the sky. He dispenses it in such a way that the balance that allows life to develop and progress is always present on Earth. Thanks to him, opposites live side by side, mixing and transforming, holding within that divine spark that allows them to exist. In the same way, he helps humans transform their negative energy into positive, which is why he is associated with prayer as a tool that favors meditation and channels energies that guide change. Sandalphon oversees not only the passage from above to below, but the inverse mechanism as well, taking the energy produced by prayers and conveying it to the heavens, where it starts a new cycle. He supervises the passage between inner and outer reality and between the human and the divine.

The Elementals:
Form and Substance

Hebrew culture considers Sandalphon an archangel associated with the Earth; but historically, in a variety of other mythologies, particularly Nordic and Anglo-Saxon, other figures, called the Elementals, govern the natural phenomena of the elements. The Elementals are the spirits of the elements: Undines are for water, Salamanders for fire, Gnomes for earth, and Sylphs for air. Their origins date to the text *De nymphis, sylphis, pygmaeis et salamandris*, written by Paracelsus, the father of alchemy, to explain nature and its laws.

The Undines live in water and enchant humans with their song, leading them to their death, just as the sirens of Ulysses did. Little is known about the Sylphs; they live in the woods, on mountain peaks, and in windy places, and they help those humans that they have chosen to protect. The Salamanders are associated with fire, and it was believed that they could resist the flames. They represent the vital principle of light, and it is believed that the Salamanders made it possible for the Gnomes, who live underground, to become part of plants and then sprout from the ground, taking on a physical form. In this sense, the Salamanders are messengers of creative order, which allows form to become substance, entrusting the order to those who have the knowledge to achieve it.

What unites these figures together remained wrapped in darkness for a long time. Many men have dedicated their lives to the dream of alchemy, searching for the philosopher's stone that, according to some interpretations, is nothing other than knowledge.

⚡ **POWERS**

Conveys wisdom | Helps those who fight for justice

URIEL

The Forgotten Archangel

THE MEANING OF HIS NAME: "Light of God," "Fire of God"

He protects the just with his flaming spade

✝ ✡ Archangel △ Planetary Angel associated with Uranus; Watcher Angel

Archangel, demon, protector, or vengeful spirit: which one is the true face of Uriel?

Uriel descended from the Garden of Eden to Hell. According to some sources, he was a Cherub, and over time his figure went from guard of the Garden of Eden with his flaming sword to keeper of the keys of Hell. His position in the angelic ranks may have changed over time and according to different sources; but what is certain is his power, which almost equals that of Michael.

In fact, Uriel is one of the four angels that "looked down from heaven and saw much blood being shed upon the earth, and all lawlessness being wrought upon the earth" (Book of Enoch, Book of Watchers 9:1) by the *Grigori*, the two hundred angels sent to Earth that corrupted themselves and humanity. The angels described in the Book of Watchers succumbed to egoism and the desires of the flesh; and when God saw what they had done, he became infuriated

and sent Michael, Gabriel, Uriel, and Suriel to exterminate the angels as well as the humans—everyone except Noah, who continued to fear God and to try to raise his family according to the religious precepts in the Old Testament. God gave Uriel the duty of warning Noah before the Great Flood. Uriel told Noah to build the famous Ark that would allow humanity to start over, in a new world, washed of their sins literally as well as metaphorically.

Another episode with Uriel tells of the reaction of the vengeful God in the Old Testament who sent the seven plagues to Egypt to punish the Egyptians because they refused to liberate the Hebrew people from slavery. Shortly before the blood and calamity spread from house to house, Uriel was sent to Earth to ensure that the doorposts of those who were not to be punished were marked with a sign in lamb's blood, a direct precursor of the rites of Easter that the three major monotheistic religions still share today.

Angel and Demon

What happened to the archangel Uriel? Why is he not included in the nine angels that head the angelic choirs? Why is he not one of the three archangels recognized by the Catholic Church?

It was a historic event that determined the oblivion of Uriel. In 745, Pope Zachary accused the Archbishop of Magdeburg of witchcraft and suspended him because he carried out magic rituals during which he invoked the angels, calling particularly for the help of Uriel. The archbishop was convicted for a miraculous prayer he had invented. In addition to known angels, it cited other angels who, after an ecclesiastical investigation, were defined first as being suspicious and later as demonic. The banishment of the archbishop provoked the decline of Uriel, whose figure was ultimately depicted in two versions, one an angel and one a demon.

Originally, the divine Unity that rules the world and all things in it did not consider a clear-cut divide between good and evil, but rather a necessary coexistence between the two opposites, according to the principle in which the visible is the measure of the invisible. What happened on Earth had to be considered in Heaven. Traces of this tradition can be found in the Testament of Solomon, an apocryphal text that tells of a number of Healing Angels who were later considered demons according to official dogma.

The 213 angels of various religious traditions presented in the following pages are introduced in alphabetical order, according to their names in Hebrew or in other sources. Their individual powers, their classification, and their culture of origin are indicated, as well as the meaning of their name when a credible hypothesis can be formulated.

The angels presented come from the Jewish-Christian culture, including the seventy-two of the biblical Tetragrammaton (with the exception of the archangels presented in the previous section). Some of the angels of the Book of Watchers and Satanael (Lucifer), the angel of evil, have been added in accordance with the ancient belief that good cannot be achieved without the presence of its opposite. Some of the angels named in the Koran are present, as are some of those described in apocryphal texts or in popular esoteric currents that have adopted elements of Assyrian-Babylonian, Zoroastrian, or Greek and Roman religions.

The list also includes guardian angels from Kabbalism, some of whom are recognized by Catholic doctrine. Because of the intertwining of their origins, angels may belong to several overlapping cultures and classifications at the same time.

The power of angels is a gift bestowed upon humans that can be invoked through prayer.

ABDIZUEL

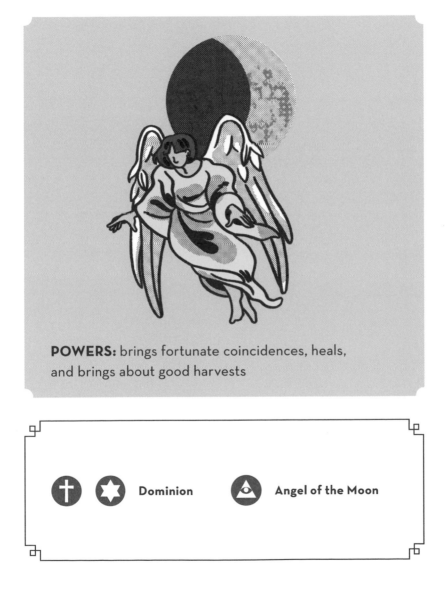

POWERS: brings fortunate coincidences, heals, and brings about good harvests

✝ ✡ **Dominion** △ **Angel of the Moon**

ACHAIAH

THE MEANING OF HIS NAME: "Good and Patient God"

POWERS: instills courage

† Seraphim

✡ Seraph and Angel of the biblical Tetragrammaton

📜 Guardian Angel of those born April 21–25

ADNACHIEL

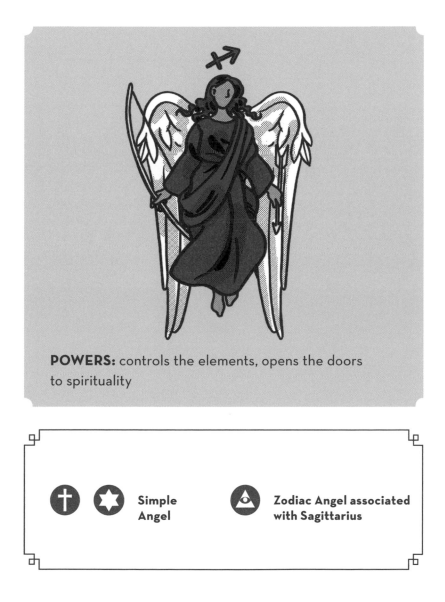

POWERS: controls the elements, opens the doors to spirituality

Simple Angel

Zodiac Angel associated with Sagittarius

ADONAEL

POWERS: heals physical and spiritual ailments

Healing Angel, according to the Testament of Solomon

ADRIEL

THE MEANING OF HIS NAME: "God's Herd"

POWERS: strengthens willpower

 Simple Angels ▲ Angel of the Moon

AKIBEEL

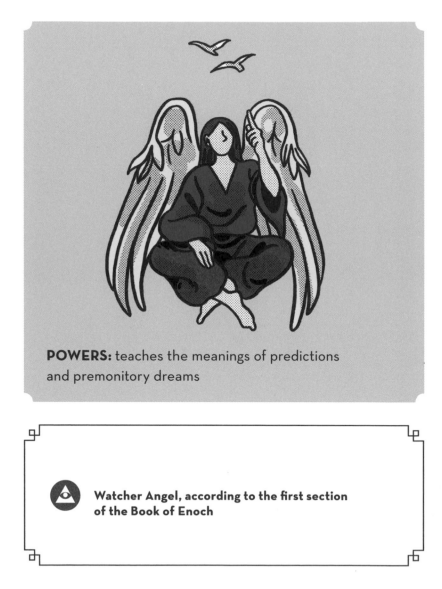

POWERS: teaches the meanings of predictions and premonitory dreams

Watcher Angel, according to the first section of the Book of Enoch

ALADIAH

THE MEANING OF HIS NAME: "Propitious and Favorable God"

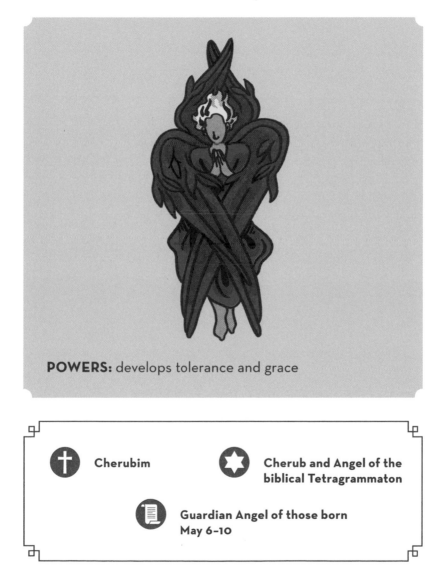

POWERS: develops tolerance and grace

✝ Cherubim

✡ Cherub and Angel of the biblical Tetragrammaton

📜 Guardian Angel of those born May 6–10

ALHENIEL

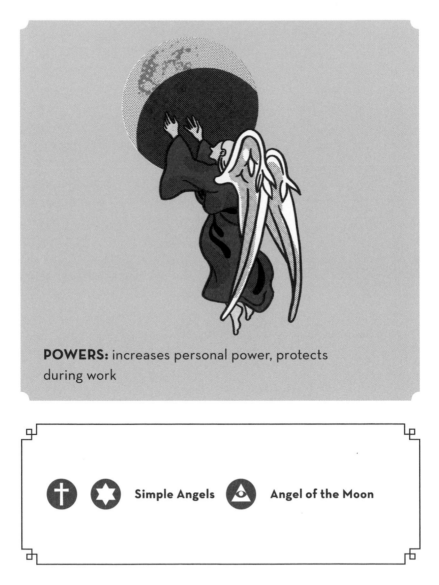

POWERS: increases personal power, protects during work

✝ ✡ **Simple Angels** 🔺 **Angel of the Moon**

AMBRIEL

THE MEANING OF HIS NAME: "God's Energy"

POWERS: helps growth and communication

✝ ✡ **Thrones** 🔺 **Zodiac Angel associated with Gemini**

AMEZARAK

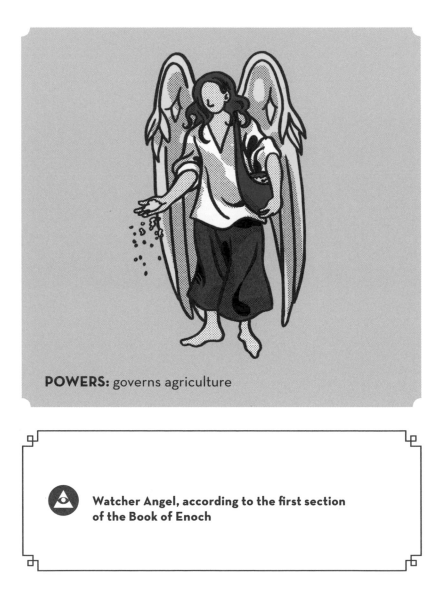

POWERS: governs agriculture

Watcher Angel, according to the first section of the Book of Enoch

AMIXIEL

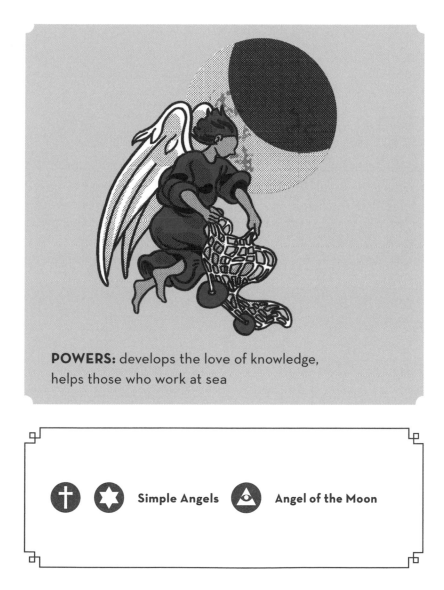

POWERS: develops the love of knowledge, helps those who work at sea

Simple Angels Angel of the Moon

AMUTIEL

POWERS: helps evade difficulties

✝ ✡ **Simple Angels** 🔺 **Angel of the Moon**

ANANAEL

THE MEANING OF HIS NAME: "Grace of God"

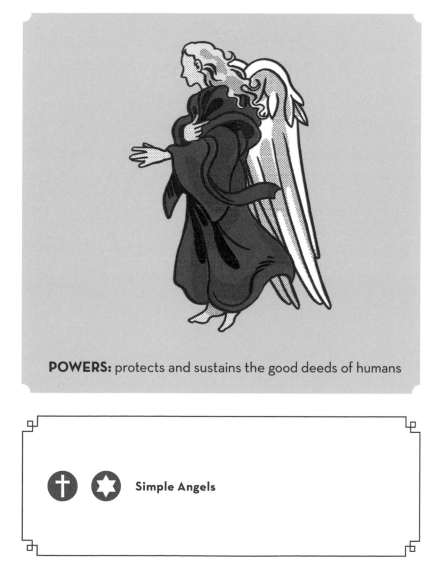

POWERS: protects and sustains the good deeds of humans

✝ ✡ **Simple Angels**

ANANI

POWERS: instills knowledge in humans

Watcher Angel, according to the first section
of the Book of Enoch

ANAUEL

THE MEANING OF HIS NAME: "Infinitely Good"

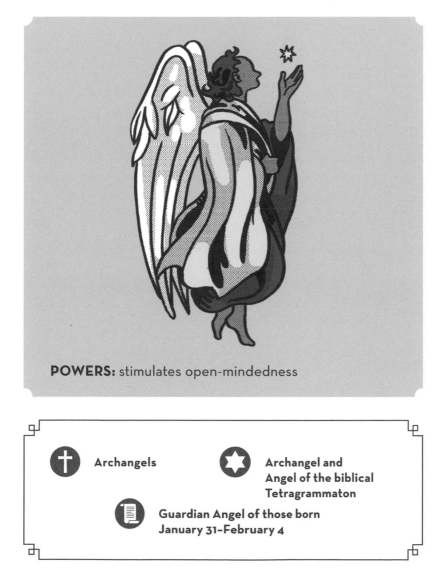

POWERS: stimulates open-mindedness

✝ **Archangels**

✡ **Archangel and Angel of the biblical Tetragrammaton**

📜 **Guardian Angel of those born January 31–February 4**

ANIEL

THE MEANING OF HIS NAME: "God of the Virtues"

POWERS: instills the courage to make change

✝ Powers

✡ Power and Angel of the biblical Tetragrammaton

📜 Guardian Angel of those born September 24–28

ARAEL

POWERS: cures ills

Healing Angel, according to the Testament of Solomon

ARAZEYAL

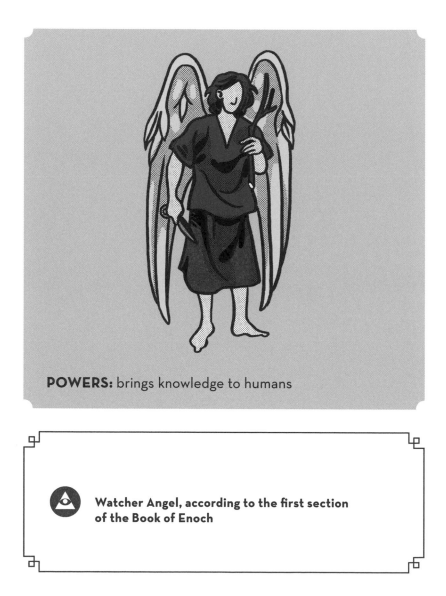

POWERS: brings knowledge to humans

Watcher Angel, according to the first section of the Book of Enoch

ARDEFIEL

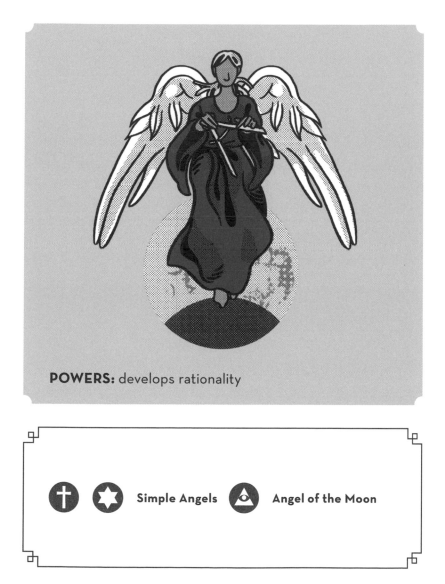

POWERS: develops rationality

✝ ✡ **Simple Angels** 🔺 **Angel of the Moon**

ARIEL

THE MEANING OF HIS NAME: "God Who Reveals"

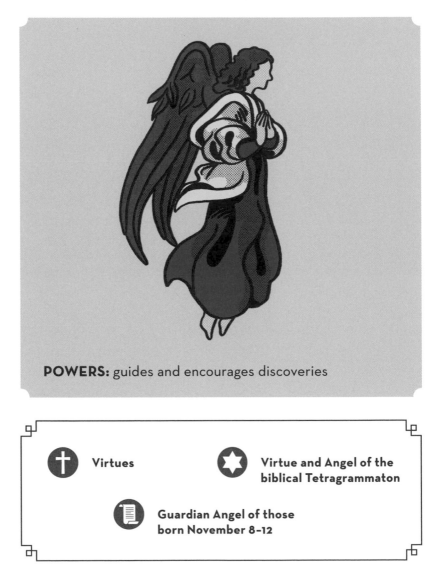

POWERS: guides and encourages discoveries

† Virtues

✡ Virtue and Angel of the biblical Tetragrammaton

📜 Guardian Angel of those born November 8-12

ARIOCH

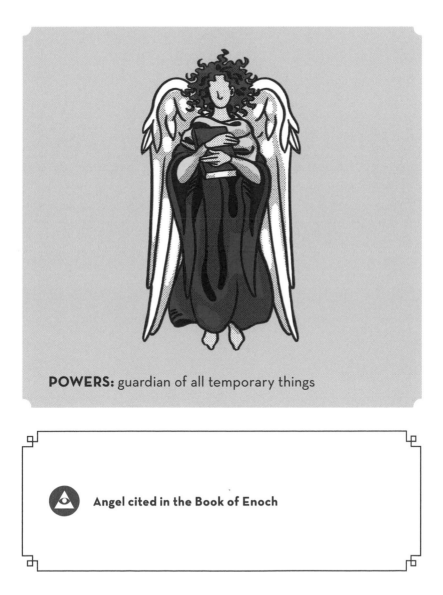

POWERS: guardian of all temporary things

Angel cited in the Book of Enoch

ARMAROS

POWERS: taught humans the dissolution of spells

Watcher Angel, according to the first section of the Book of Enoch

ARMERS

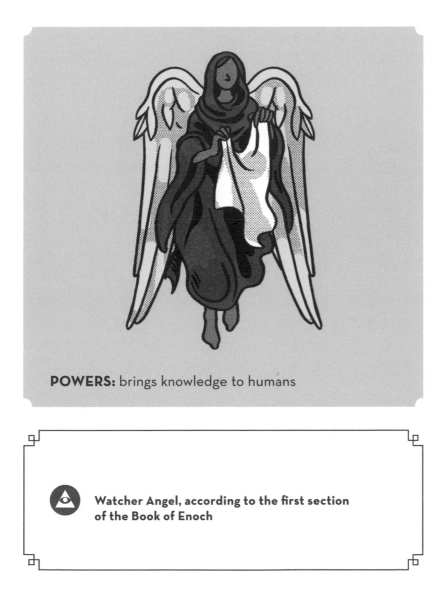

POWERS: brings knowledge to humans

Watcher Angel, according to the first section
of the Book of Enoch

ARSEYALEYOR

POWERS: brings knowledge to humans

Watcher Angel, according to the first section
of the Book of Enoch

ASAEL

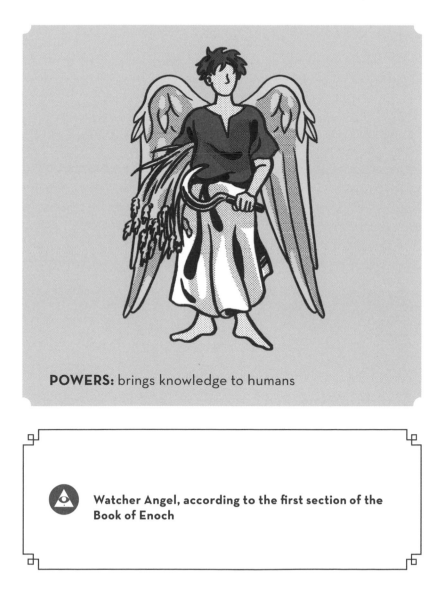

POWERS: brings knowledge to humans

Watcher Angel, according to the first section of the Book of Enoch

ASALIAH

THE MEANING OF HIS NAME: "God Who Indicates the Truth"

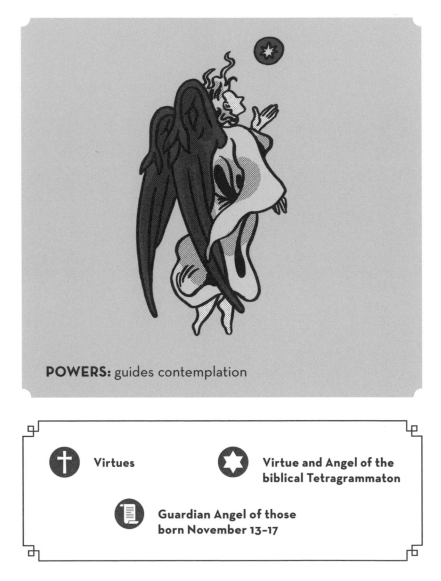

POWERS: guides contemplation

✝ Virtues

✡ Virtue and Angel of the biblical Tetragrammaton

📜 Guardian Angel of those born November 13–17

ASMODEL

POWERS: helps with hearing problems

✝ ✡ **Cherubim** 👁 **Zodiac Angel associated with Taurus**

ASRADEL

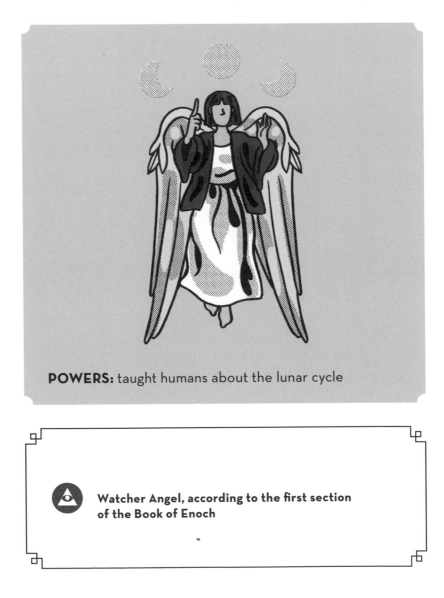

POWERS: taught humans about the lunar cycle

Watcher Angel, according to the first section of the Book of Enoch

ATALIEL

POWERS: favors earnings

✝ ✡ **Simple Angels** 👁 **Angel of the Moon**

AZARIEL

THE MEANING OF HIS NAME: "Help of God"

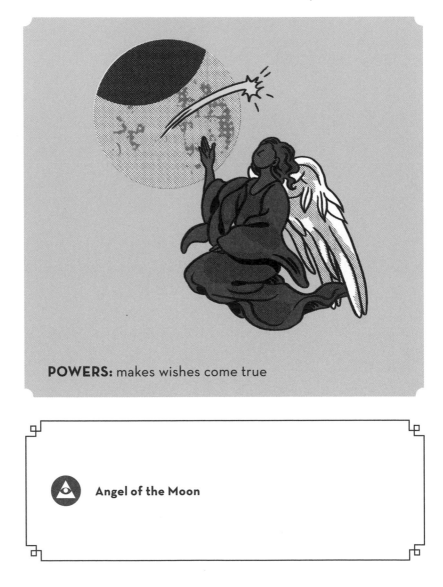

POWERS: makes wishes come true

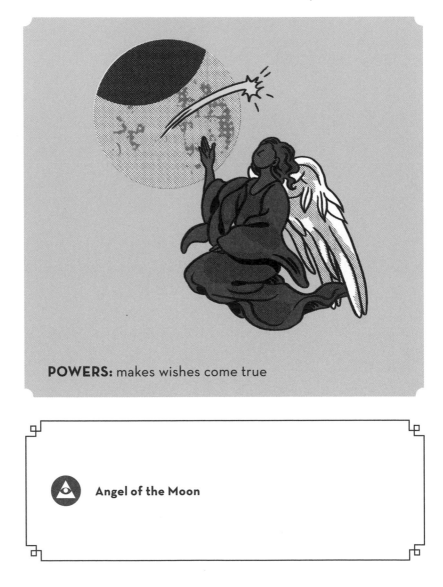 **Angel of the Moon**

AZAZEL

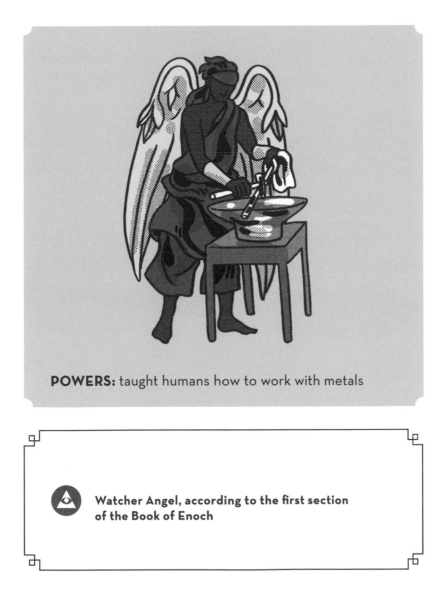

POWERS: taught humans how to work with metals

Watcher Angel, according to the first section of the Book of Enoch

AZERUEL

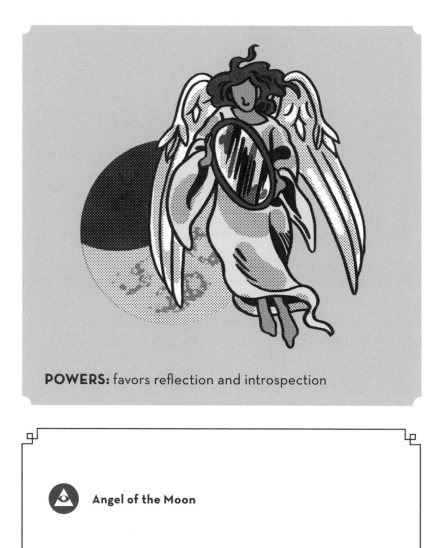

POWERS: favors reflection and introspection

Angel of the Moon

AZIEL

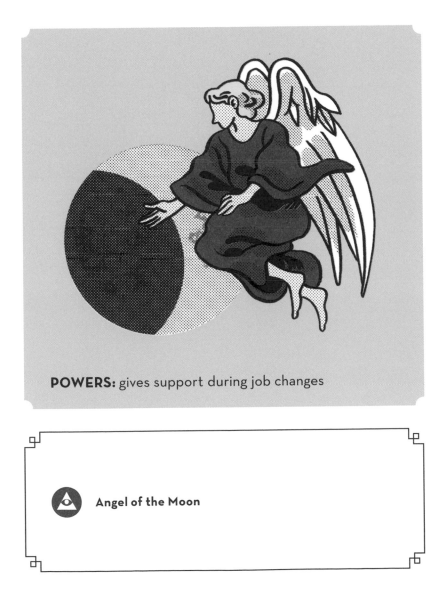

POWERS: gives support during job changes

Angel of the Moon

AZRA'IL

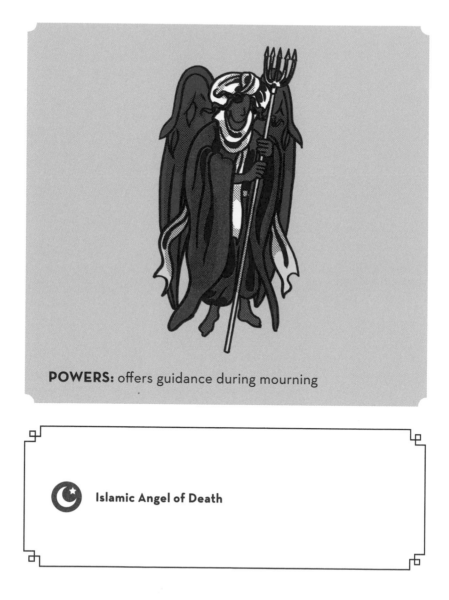

POWERS: offers guidance during mourning

Islamic Angel of Death

BARADIEL

POWERS: governs hail and ice

Angel of Hail in the Book of Enoch

BARAQAL

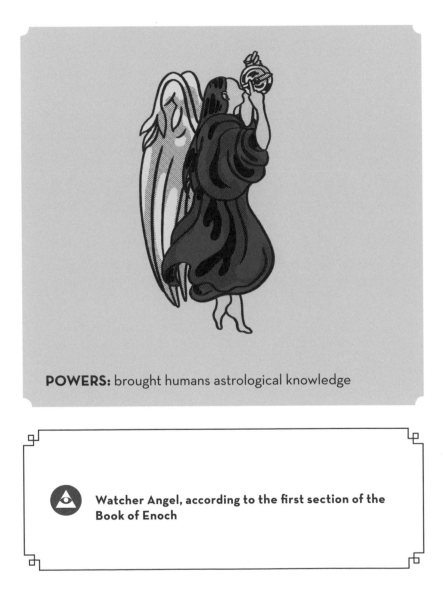

POWERS: brought humans astrological knowledge

Watcher Angel, according to the first section of the Book of Enoch

BARAQUEL

THE MEANING OF HIS NAME: "God's Lightning"

POWERS: governs the phenomenon of lightning

✝ ✡ **Simple Angels** 🔺 **Angel Prince of lightning in the Book of Enoch**

BARBIEL

THE MEANING OF HIS NAME: "Honesty of God"

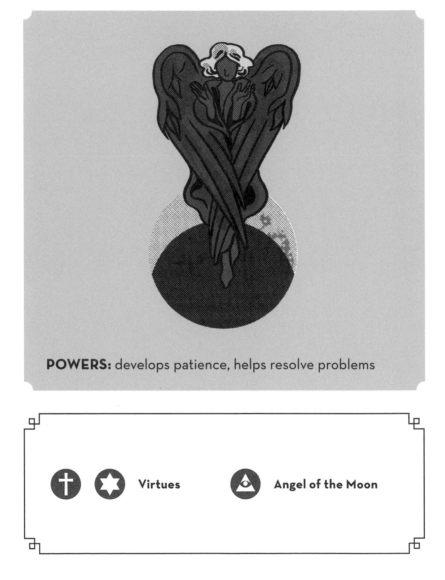

POWERS: develops patience, helps resolve problems

Virtues

Angel of the Moon

BARCHIEL

THE MEANING OF HIS NAME: "God's Beatitude"

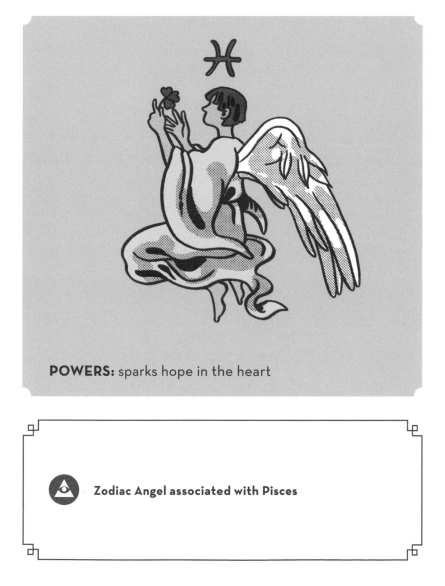

POWERS: sparks hope in the heart

Zodiac Angel associated with Pisces

BARINAEL

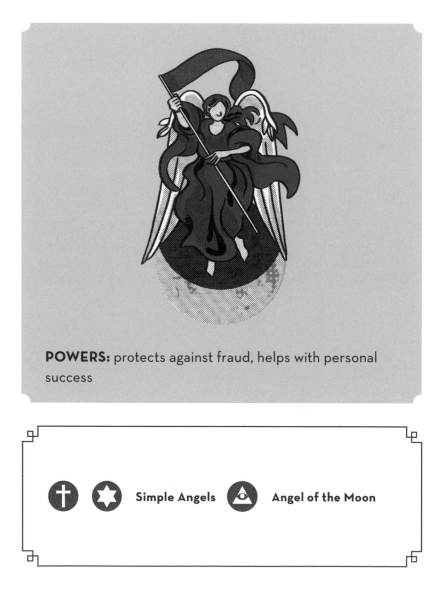

POWERS: protects against fraud, helps with personal success

† ✦ **Simple Angels** ◮ **Angel of the Moon**

BATRAAL

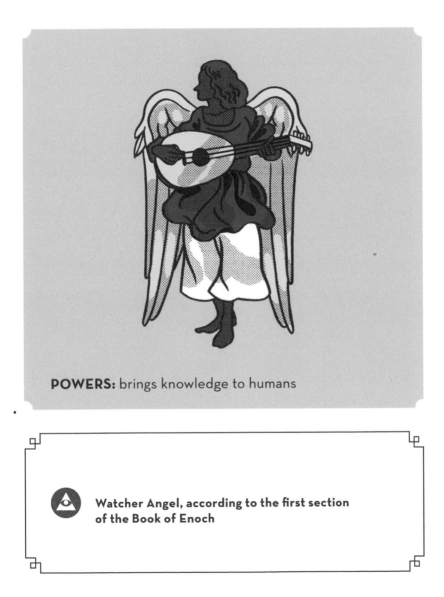

POWERS: brings knowledge to humans

Watcher Angel, according to the first section of the Book of Enoch

BETHNAEL

POWERS: helps find stability and well-being

✝ ✡ **Simple Angels** 🔺 **Angel of the Moon**

BITAEL

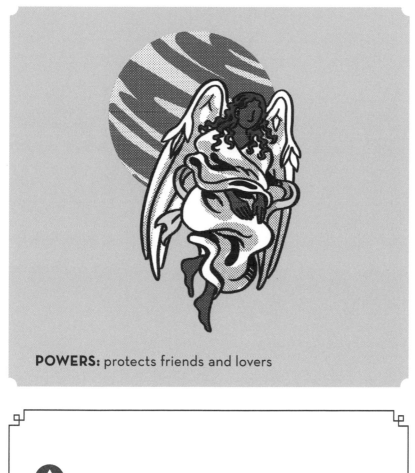

POWERS: protects friends and lovers

Angel of Venus, according to the ancient sect of the Sabians of Harran

CAHETEL

THE MEANING OF HIS NAME: "Adorable God"

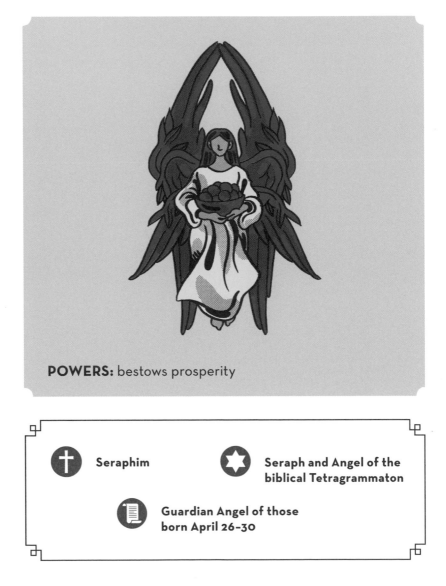

POWERS: bestows prosperity

✝ Seraphim

✡ Seraph and Angel of the biblical Tetragrammaton

📜 Guardian Angel of those born April 26–30

CALIEL

THE MEANING OF HIS NAME: "God Ready to Help and Answer"

POWERS: issues justice

✝ **Thrones**

✡ **Throne and Angel of the biblical Tetragrammaton**

📜 **Guardian Angel of those born June 16–21**

CHAIRUM

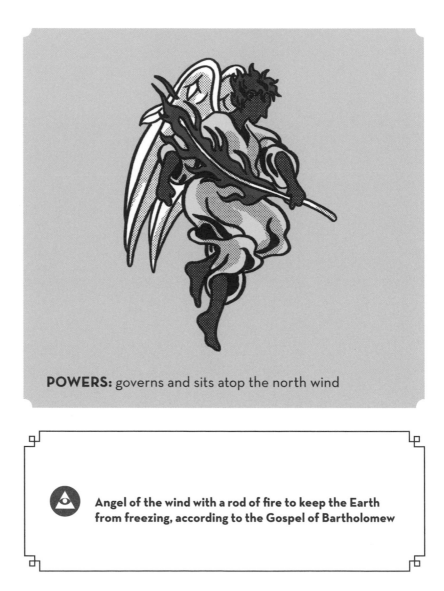

POWERS: governs and sits atop the north wind

Angel of the wind with a rod of fire to keep the Earth from freezing, according to the Gospel of Bartholomew

CHALKATURA

POWERS: protects against evil

One of the angels who fight against evil, according to the Gospel of Bartholomew

CHARUTH

POWERS: protects against evil, maintains balance on Earth

One of the angels who fight against evil, according to the Gospel of Bartholomew

CHAVAQUIAH

THE MEANING OF HIS NAME: "God Who Brings Joy"

POWERS: bestows the power of reconciliation

✝ Powers

✡ Powers and Angel of the biblical Tetragrammaton

📜 Guardian Angel of those born September 13–17

DAMABIAH

THE MEANING OF HIS NAME: "God Spring of Wisdom"

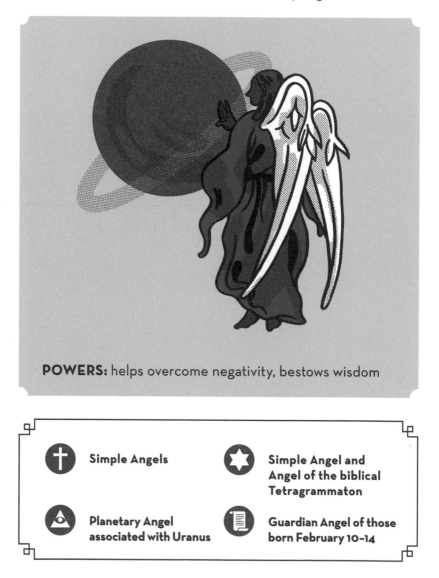

POWERS: helps overcome negativity, bestows wisdom

✝ Simple Angels

✡ Simple Angel and Angel of the biblical Tetragrammaton

△ Planetary Angel associated with Uranus

📜 Guardian Angel of those born February 10–14

DANEL

THE MEANING OF HIS NAME: "God Is the Judge"

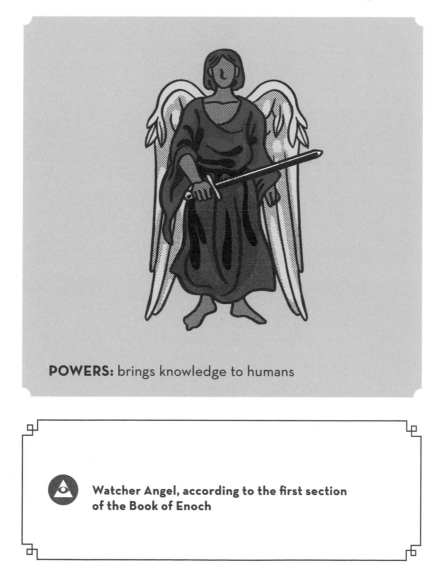

POWERS: brings knowledge to humans

Watcher Angel, according to the first section of the Book of Enoch

DANIEL

THE MEANING OF HIS NAME: "Dream of Mercy"

POWERS: improves communication abilities

✝ **Principalities**

✡ **Principality and Angel of the biblical Tetragrammaton**

📜 **Guardian Angel of those born November 28–December 2**

DIRACHIEL

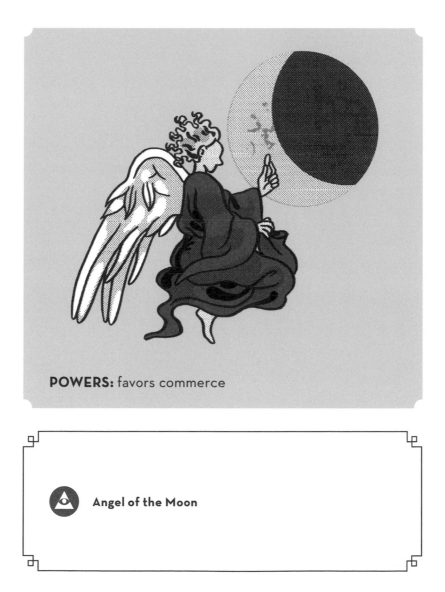

POWERS: favors commerce

Angel of the Moon

DUTH

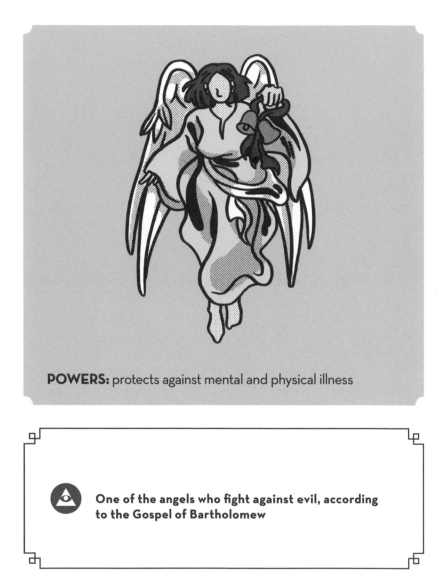

POWERS: protects against mental and physical illness

One of the angels who fight against evil, according to the Gospel of Bartholomew

EGIBIEL

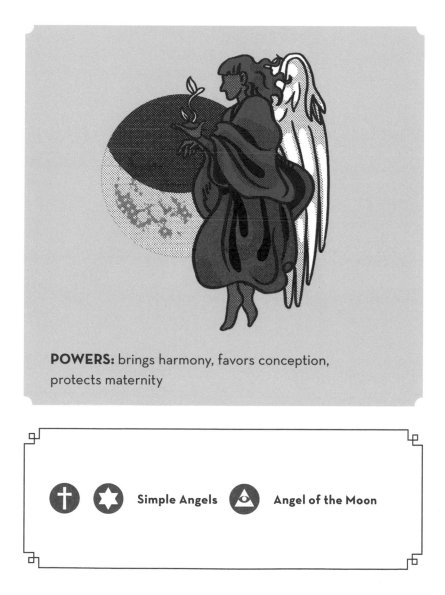

POWERS: brings harmony, favors conception, protects maternity

🕇 ✡ **Simple Angels** 🜂 **Angel of the Moon**

ELEMIAH

THE MEANING OF HIS NAME: "God Is a Haven"

POWERS: helps attain power

✝ **Seraphim**

✡ **Seraph and Angel of the biblical Tetragrammaton**

📜 **Guardian Angel of those born April 5–9**

ENEDIEL

POWERS: provides divine aid, helps find lost objects

✝ ✡ **Simple Angels** 🔺 **Angel of the Moon**

ERGEDIEL

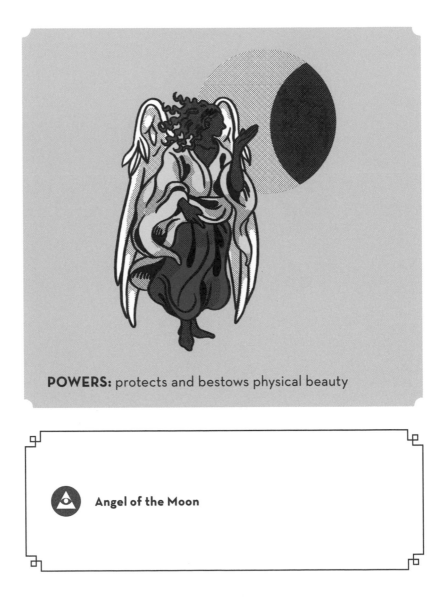

POWERS: protects and bestows physical beauty

Angel of the Moon

EYAEL

THE MEANING OF HIS NAME: "God the Delight of Children and Adults"

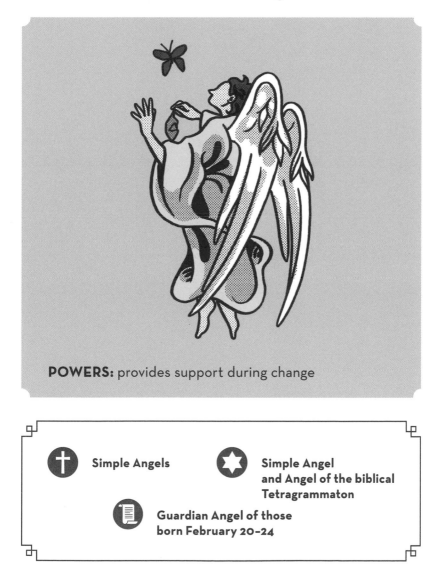

POWERS: provides support during change

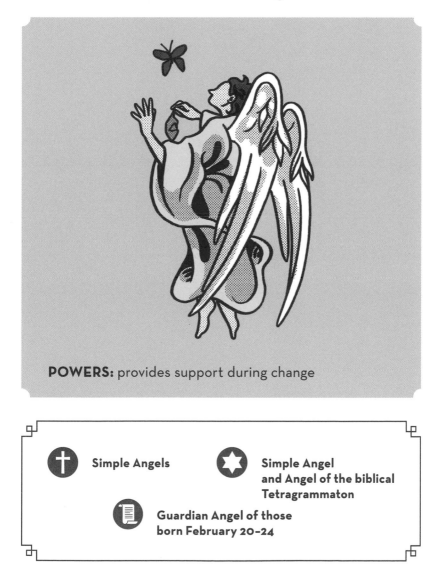 **Simple Angels**

Simple Angel and Angel of the biblical Tetragrammaton

Guardian Angel of those born February 20-24

EZEQEEL

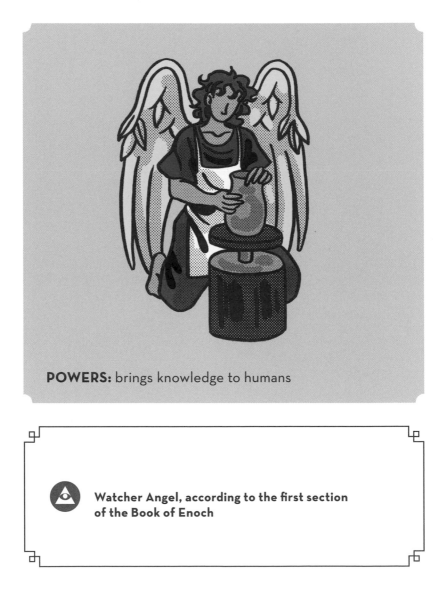

POWERS: brings knowledge to humans

Watcher Angel, according to the first section
of the Book of Enoch

FANUEL

THE MEANING OF HIS NAME: "Angel of Penitence"

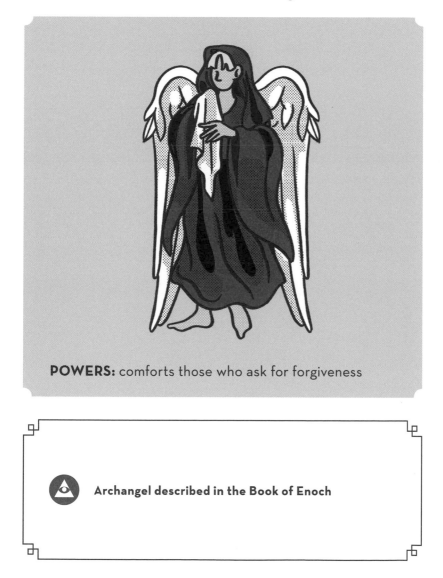

POWERS: comforts those who ask for forgiveness

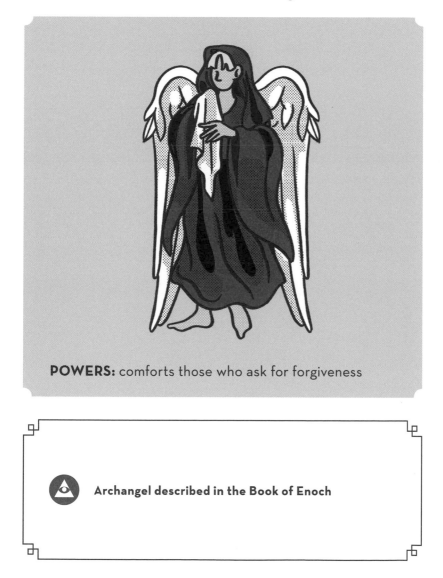 **Archangel described in the Book of Enoch**

GALGALIEL

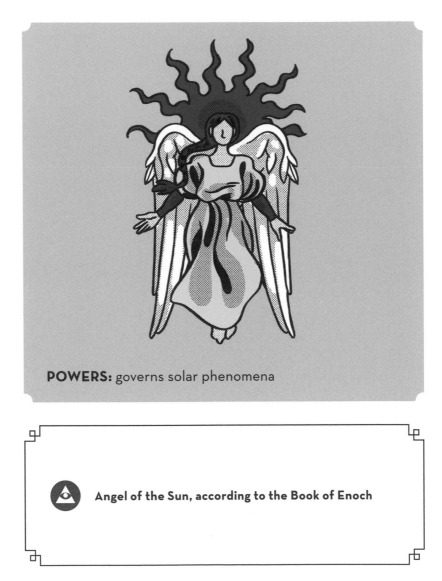

POWERS: governs solar phenomena

Angel of the Sun, according to the Book of Enoch

GARRUBIEL

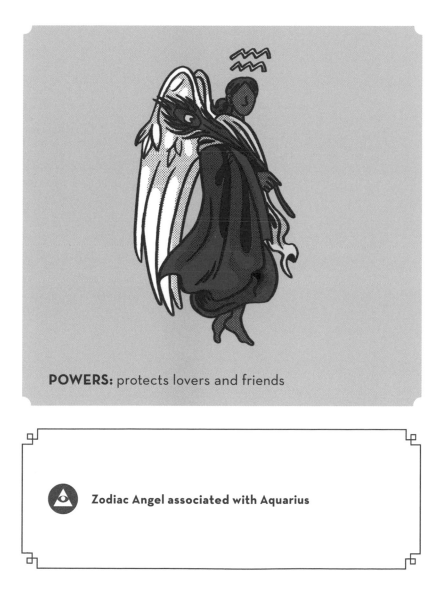

POWERS: protects lovers and friends

Zodiac Angel associated with Aquarius

GELIEL

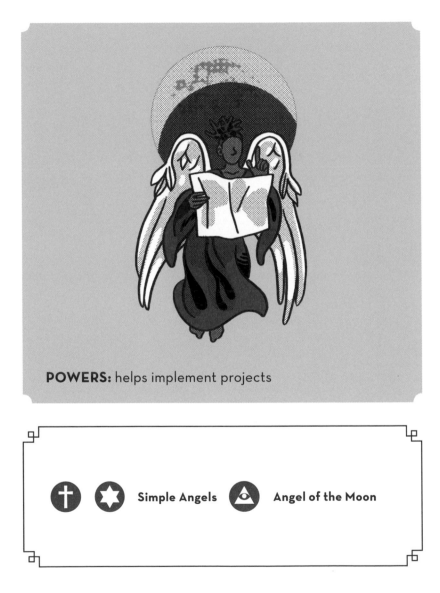

POWERS: helps implement projects

✝ ✡ **Simple Angels** △ **Angel of the Moon**

GENIEL

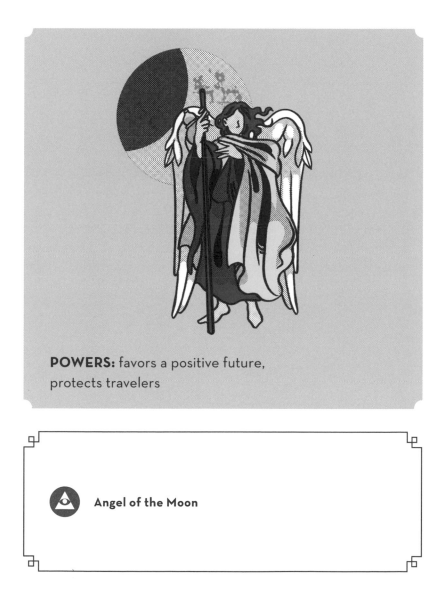

POWERS: favors a positive future, protects travelers

Angel of the Moon

GRAFATHAS

POWERS: fights against evil, protects humans

One of the angels that fight against evil, according to the Gospel of Bartholomew

HAAIAH

THE MEANING OF HIS NAME: "God of Shelter"

POWERS: helps with diplomatic capabilities, instills a sense of justice

† Dominion

✡ Dominion and Angel of the biblical Tetragrammaton

📜 Guardian Angel of those born July 28–August 1

HAAMIAH

THE MEANING OF HIS NAME: "God the Hope of All Children of the Earth"

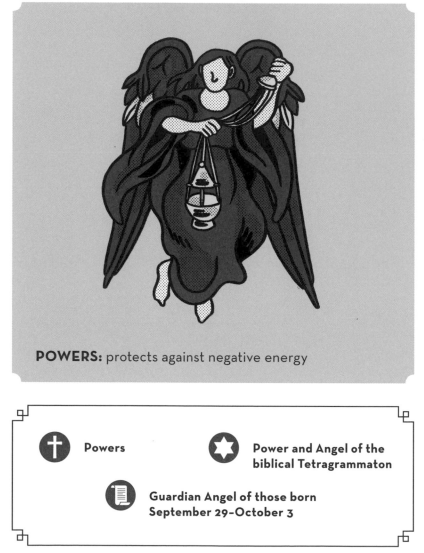

POWERS: protects against negative energy

✝ Powers

✦ Power and Angel of the biblical Tetragrammaton

📜 Guardian Angel of those born September 29–October 3

HABUHIAH

THE MEANING OF HIS NAME: "God Who Gives Freely"

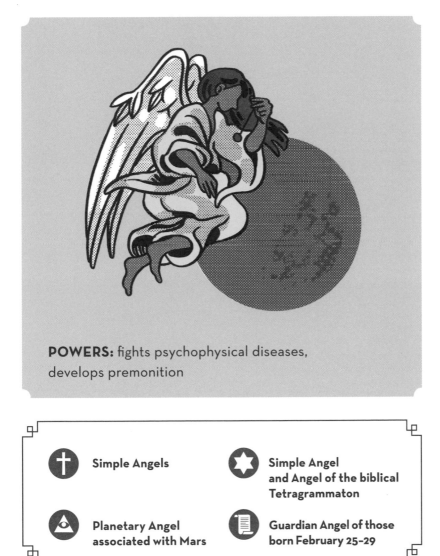

POWERS: fights psychophysical diseases, develops premonition

✝ Simple Angels

✡ Simple Angel and Angel of the biblical Tetragrammaton

△ Planetary Angel associated with Mars

📄 Guardian Angel of those born February 25–29

HAHAIAH

THE MEANING OF HIS NAME: "God of Shelter"

POWERS: protects from adversities, bestows wisdom

✝ Cherubim

✡ Cherub and Angel of the biblical Tetragrammaton

📜 Guardian Angel of those born May 16–20

HAHASIAH

THE MEANING OF HIS NAME: "Hidden God"

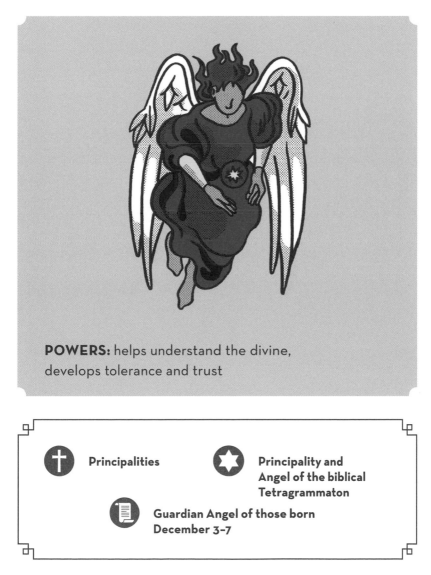

POWERS: helps understand the divine, develops tolerance and trust

Principalities

Principality and Angel of the biblical Tetragrammaton

Guardian Angel of those born December 3–7

HAHEUIAH

THE MEANING OF HIS NAME: "God Good in and of Himself"

POWERS: protects humans

✝	Thrones	✡	Throne and Angel of the biblical Tetragrammaton
📜	Guardian Angel of those born July 17–22		

HAIAIEL

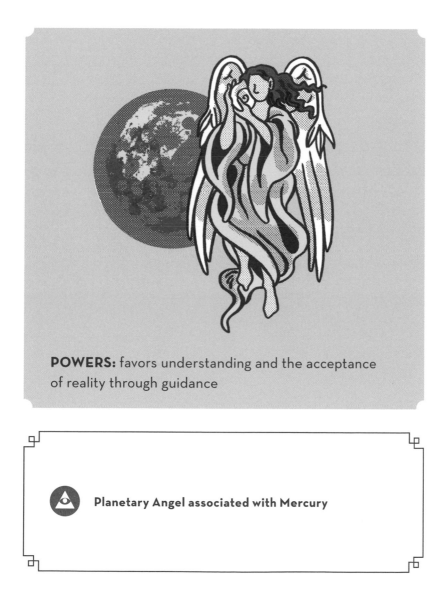

POWERS: favors understanding and the acceptance of reality through guidance

Planetary Angel associated with Mercury

HAIAYEL

THE MEANING OF HIS NAME: "God Lord of the Universe"

POWERS: increases motivation

✝	Simple Angels	✡	Simple Angel and Angel of the biblical Tetragrammaton
		📜	Guardian Angel of those born March 11–15

HAMABIEL

POWERS: supports those who have taken a vow of chastity, bestows purity of heart

| | | Virtues | | Zodiac Angel associated with Virgo |

HAMAEL

POWERS: favors and bestows the strength to persist

Zodiac Angel associated with Capricorn

HARAEL

THE MEANING OF HIS NAME: "Omniscient God"

POWERS: bestows knowledge, helps in intellectual activities

✝ **Archangels**

✡ **Archangel and Angel of the biblical Tetragrammaton**

📜 **Guardian Angel of those born January 11–15**

HARAQIEL

POWERS: magnetizes the colors green and blue

 Planetary Angel associated with Mercury, according to the ancient sect of the Sabians of Harran

HARIEL

THE MEANING OF HIS NAME: "God the Creator"

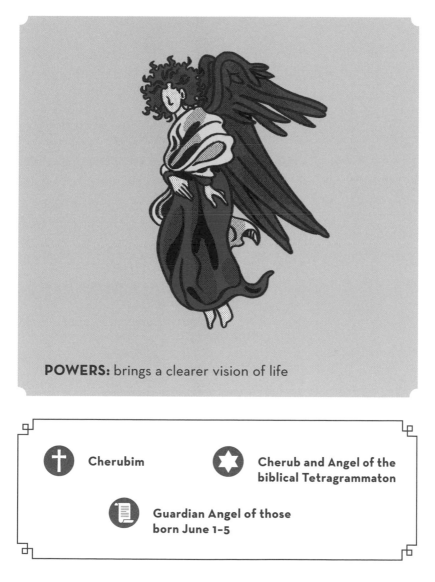

POWERS: brings a clearer vision of life

✝ Cherubim

✡ Cherub and Angel of the biblical Tetragrammaton

📜 Guardian Angel of those born June 1–5

HARUT

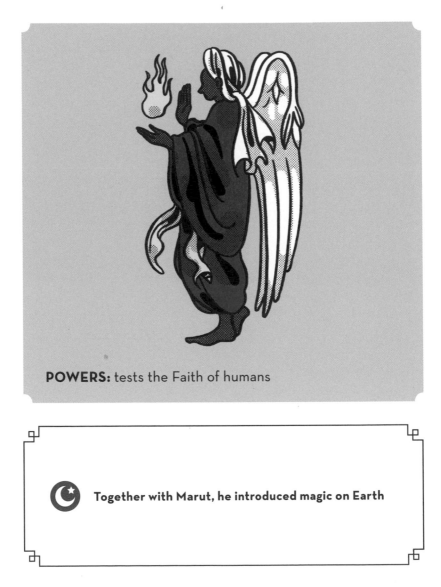

POWERS: tests the Faith of humans

Together with Marut, he introduced magic on Earth

HAZIEL

THE MEANING OF HIS NAME: "Merciful God"

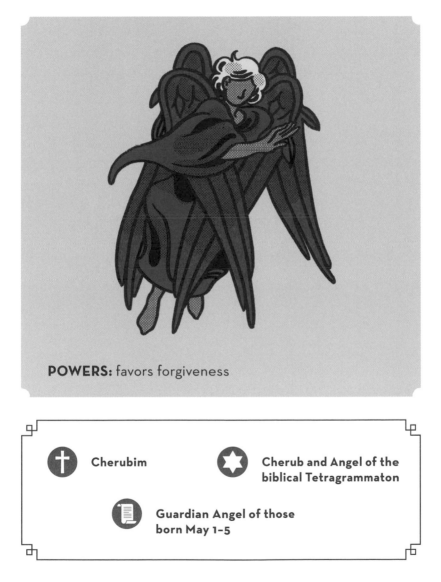

POWERS: favors forgiveness

✝ Cherubim

✡ Cherub and Angel of the biblical Tetragrammaton

📜 Guardian Angel of those born May 1–5

HEHAHEL

THE MEANING OF HIS NAME: "God in Three Persons"

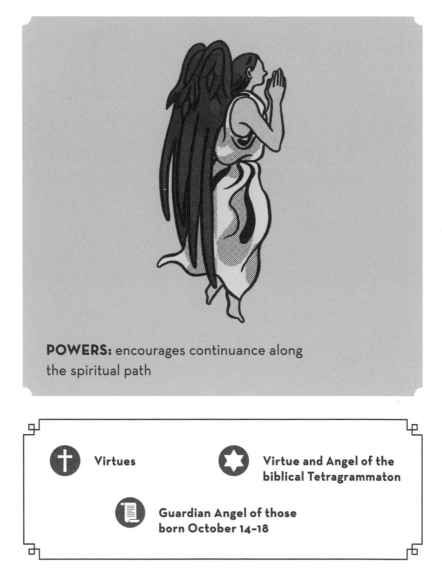

POWERS: encourages continuance along the spiritual path

✝ Virtues

✡ Virtue and Angel of the biblical Tetragrammaton

📜 Guardian Angel of those born October 14-18

HEKAMIAH

THE MEANING OF HIS NAME: "God Edifier of the Universe"

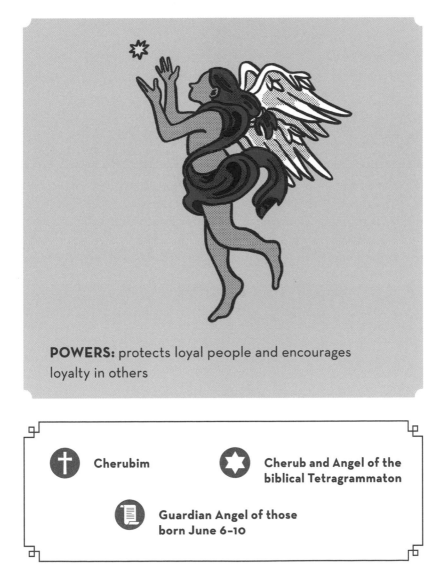

POWERS: protects loyal people and encourages loyalty in others

✝ Cherubim

✡ Cherub and Angel of the biblical Tetragrammaton

📜 Guardian Angel of those born June 6–10

IAHHEL

THE MEANING OF HIS NAME: "Supreme Being"

POWERS: favors knowledge

✝ Archangels

✡ Archangel and Angel of the biblical Tetragrammaton

📜 Guardian Angel of those born January 26–30

IAOTH

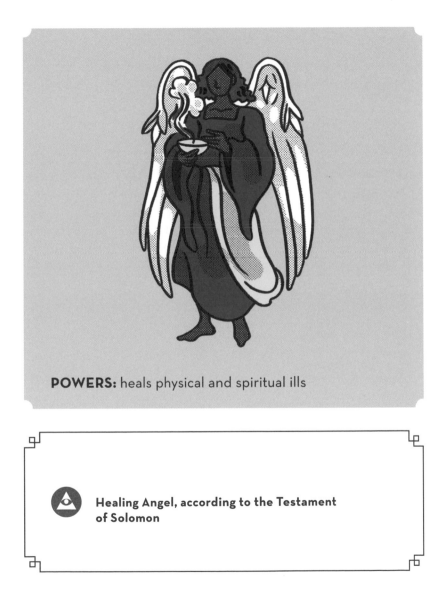

POWERS: heals physical and spiritual ills

Healing Angel, according to the Testament of Solomon

IAX

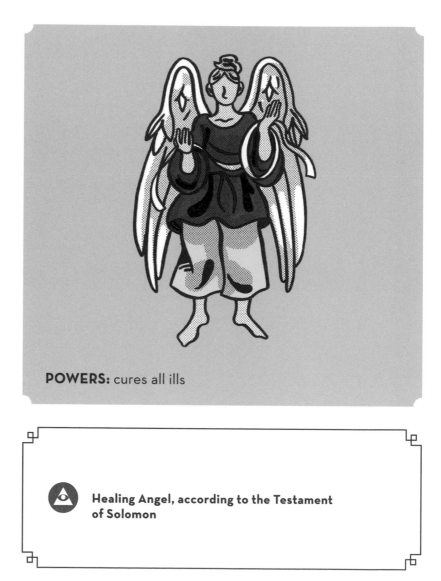

POWERS: cures all ills

Healing Angel, according to the Testament of Solomon

IEIAZEL

THE MEANING OF HIS NAME: "God Who Elates"

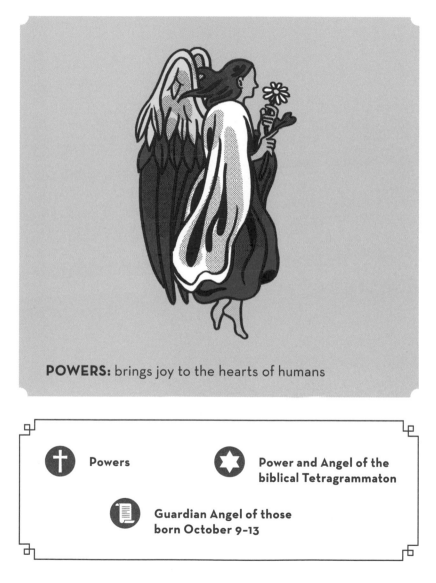

POWERS: brings joy to the hearts of humans

✝ Powers

✡ Power and Angel of the biblical Tetragrammaton

📜 Guardian Angel of those born October 9–13

IEZALEL

THE MEANING OF HIS NAME: "God Glorifies All Things"

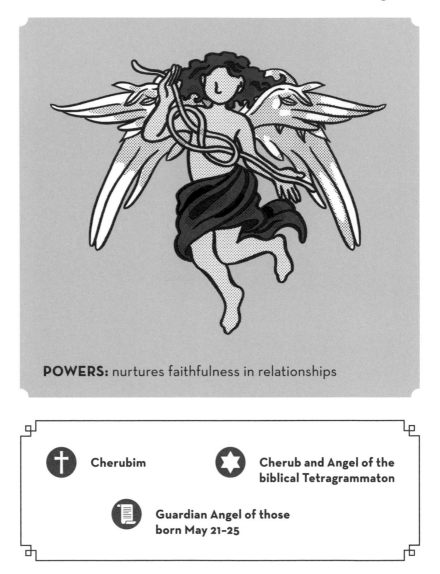

POWERS: nurtures faithfulness in relationships

✝ Cherubim

✡ Cherub and Angel of the biblical Tetragrammaton

📜 Guardian Angel of those born May 21–25

IMAMIAH

THE MEANING OF HIS NAME: "God Elevates above All Things"

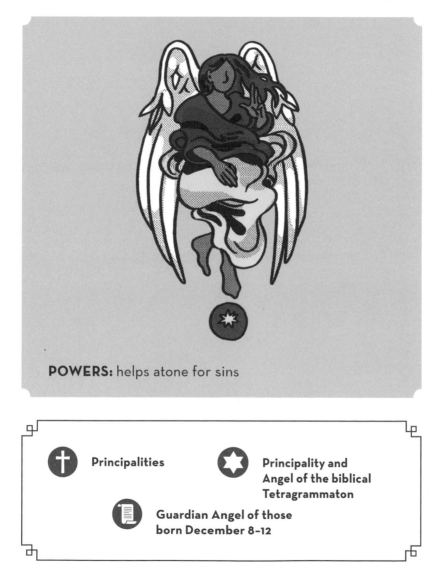

POWERS: helps atone for sins

✝ **Principalities**

✡ **Principality and Angel of the biblical Tetragrammaton**

📜 **Guardian Angel of those born December 8–12**

ISBAL

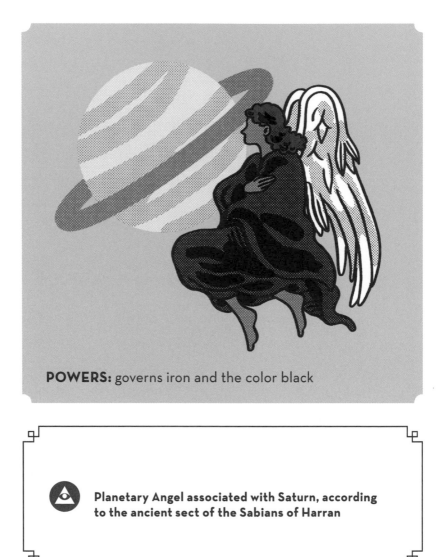

POWERS: governs iron and the color black

Planetary Angel associated with Saturn, according to the ancient sect of the Sabians of Harran

ISRAFIL

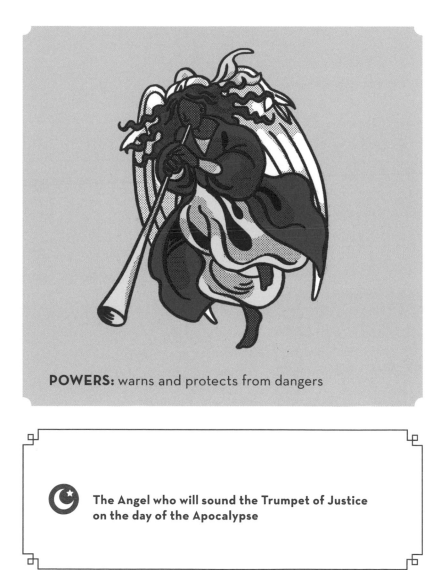

POWERS: warns and protects from dangers

The Angel who will sound the Trumpet of Justice on the day of the Apocalypse

JABAMIAH

THE MEANING OF HIS NAME: "The Word That Produces All Things"

POWERS: brings inner harmony and helps regeneration

Simple Angels

Simple Angel and Angel of the biblical Tetragrammaton

Planetary Angel associated with Venus

Guardian Angel of those born March 6-10

JAZERIEL

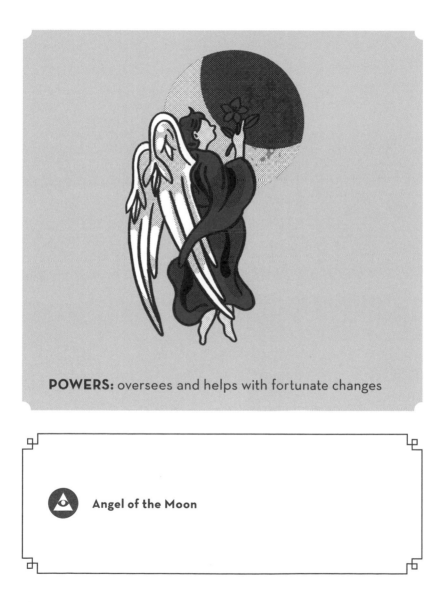

POWERS: oversees and helps with fortunate changes

Angel of the Moon

JEHUDIEL

THE MEANING OF HIS NAME: "Glory of God"

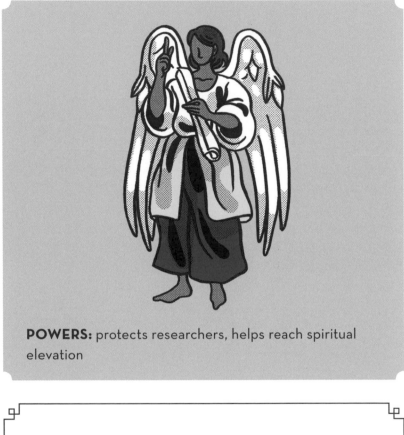

POWERS: protects researchers, helps reach spiritual elevation

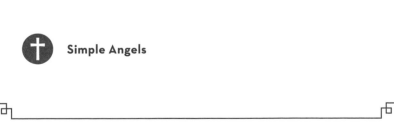

✝ **Simple Angels**

JELIEL

THE MEANING OF HIS NAME: "Charitable God"

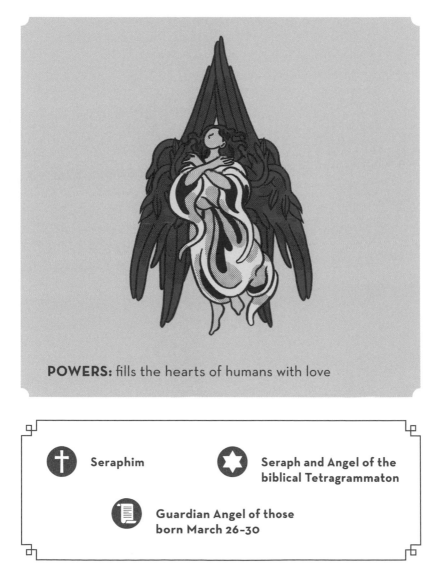

POWERS: fills the hearts of humans with love

† Seraphim

✡ Seraph and Angel of the biblical Tetragrammaton

📜 Guardian Angel of those born March 26–30

JOPHIEL

THE MEANING OF HIS NAME: "God's Emissary"

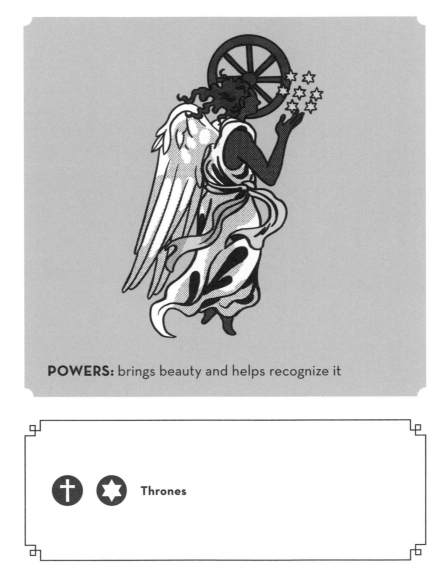

POWERS: brings beauty and helps recognize it

✝ ✡ **Thrones**

KARAEL

POWERS: heals physical and spiritual ills

Healing Angel, according to the Testament of Solomon

KERKUTHA

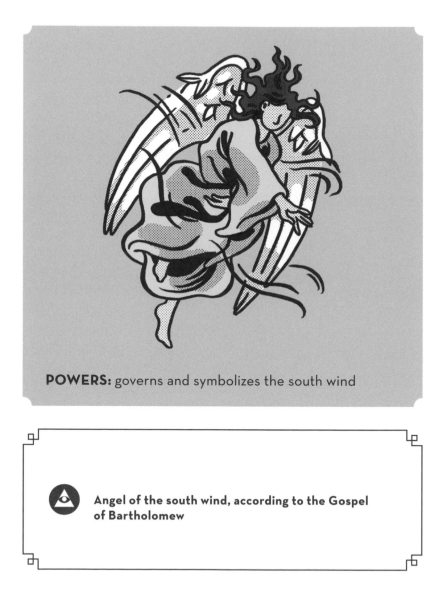

POWERS: governs and symbolizes the south wind

Angel of the south wind, according to the Gospel of Bartholomew

KJRIEL

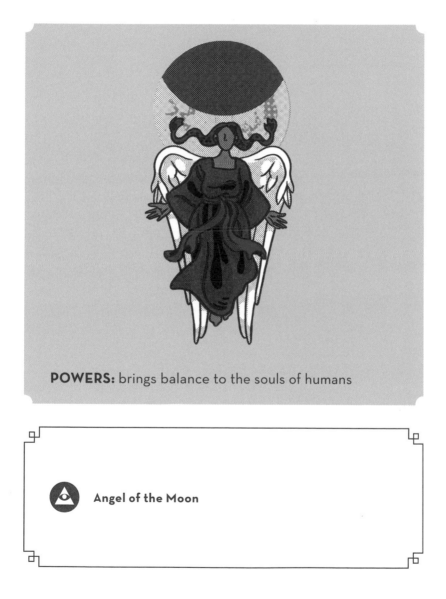

POWERS: brings balance to the souls of humans

Angel of the Moon

KOBABEL

POWERS: brings knowledge to humans

Watcher Angel, according to the first section of the Book of Enoch

KOKBIEL

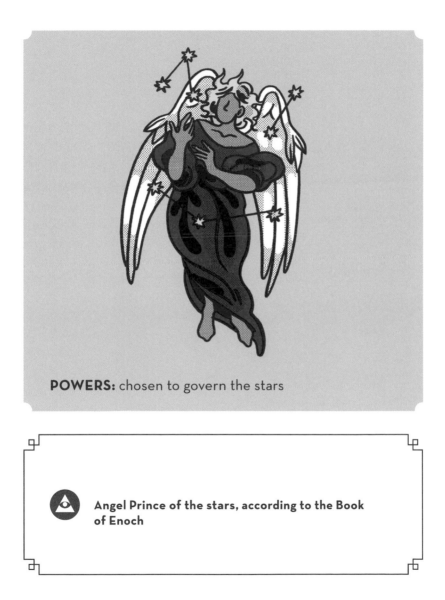

POWERS: chosen to govern the stars

Angel Prince of the stars, according to the Book of Enoch

LAUVIAH

THE MEANING OF HIS NAME: "Admirable God"

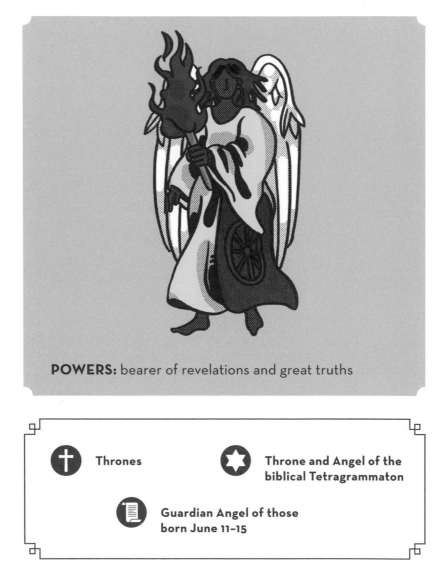

POWERS: bearer of revelations and great truths

✝ Thrones

✡ Throne and Angel of the biblical Tetragrammaton

📜 Guardian Angel of those born June 11–15

LAVIAH

THE MEANING OF HIS NAME: "God Praises and Exalts"

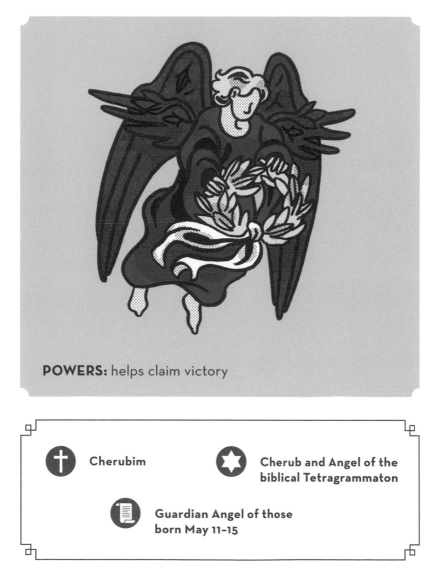

POWERS: helps claim victory

✝ **Cherubim**

✡ **Cherub and Angel of the biblical Tetragrammaton**

📜 **Guardian Angel of those born May 11–15**

LAYLAHEL

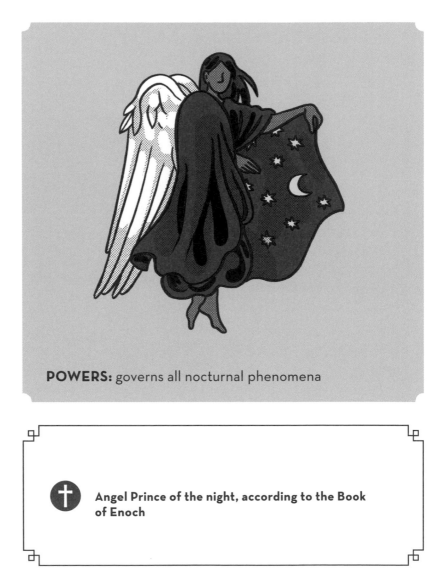

POWERS: governs all nocturnal phenomena

✝ **Angel Prince of the night, according to the Book of Enoch**

LECABEL

THE MEANING OF HIS NAME: "God Who Inspires"

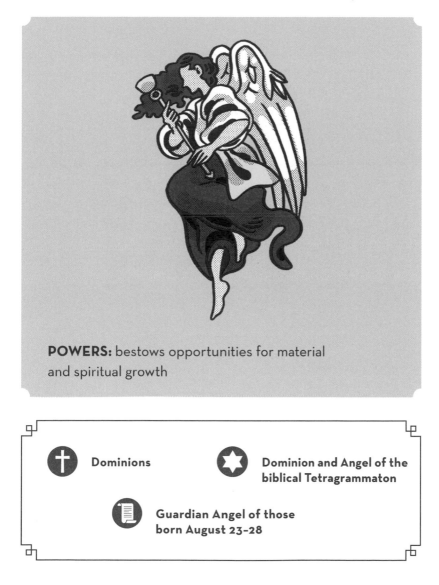

POWERS: bestows opportunities for material and spiritual growth

✝ **Dominions**

✡ **Dominion and Angel of the biblical Tetragrammaton**

📜 **Guardian Angel of those born August 23–28**

LEHAHIAH

THE MEANING OF HIS NAME: "Clement God"

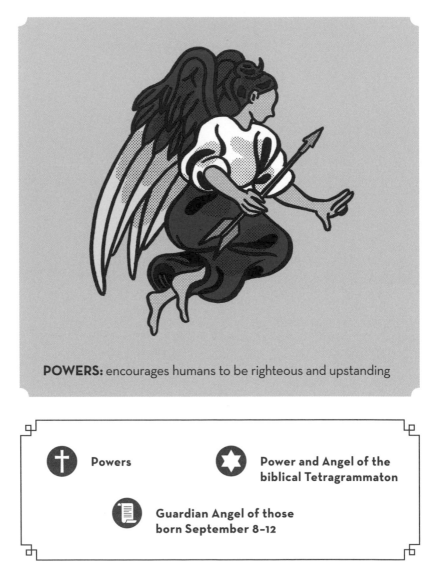

POWERS: encourages humans to be righteous and upstanding

✝ Powers

✡ Power and Angel of the biblical Tetragrammaton

📜 Guardian Angel of those born September 8–12

LELAHEL

THE MEANING OF HIS NAME: "God the Praiseworthy"

POWERS: brings light to life and to the mind

✝ Seraphim

✡ Seraph and Angel of the biblical Tetragrammaton

📜 Guardian Angel of those born April 15–20

LEUVIAH

THE MEANING OF HIS NAME: "God Who Answers the Sinners"

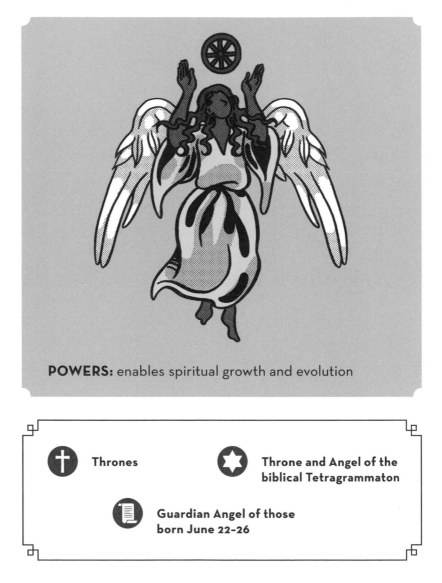

POWERS: enables spiritual growth and evolution

✝ **Thrones**

✡ **Throne and Angel of the biblical Tetragrammaton**

📜 **Guardian Angel of those born June 22–26**

MAHASIAH

THE MEANING OF HIS NAME: "God the Savior"

POWERS: purifies the mind, helps purify the heart

✝ Seraphim

✡ Seraph and Angel of the biblical Tetragrammaton

📜 Guardian Angel of those born April 10–14

MALCHIDAEL

THE MEANING OF HIS NAME: "Angel of Spring"

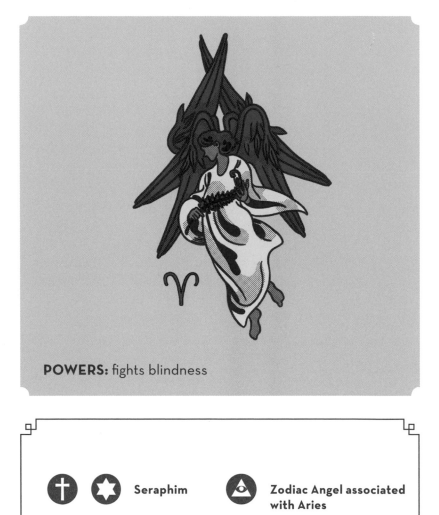

POWERS: fights blindness

Seraphim

Zodiac Angel associated with Aries

MALIK

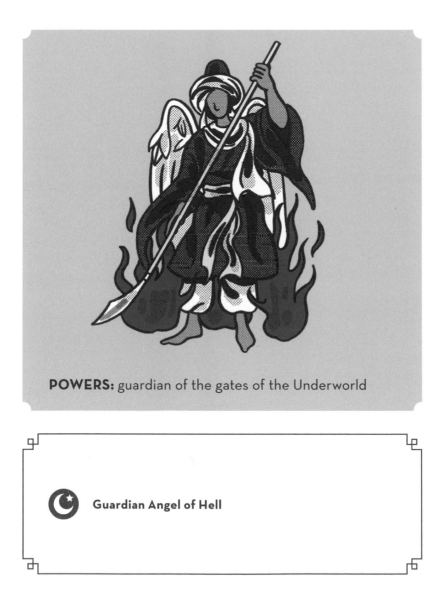

POWERS: guardian of the gates of the Underworld

Guardian Angel of Hell

MANAKEL

THE MEANING OF HIS NAME: "God Who Nurtures All Things"

POWERS: fights sadness, stimulates creativity, brings knowledge

✝ **Simple Angels**

✡ **Simple Angel and Angel of the biblical Tetragrammaton**

△ **Planetary Angel associated with Saturn**

▤ **Guardian Angel of those born February 15–19**

MANEDIEL

THE MEANING OF HIS NAME: "Merciful God"

POWERS: instills courage

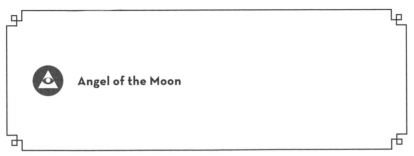

Angel of the Moon

MARIOCH

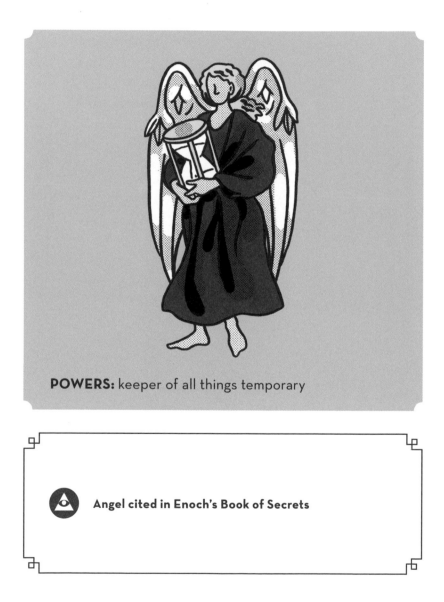

POWERS: keeper of all things temporary

Angel cited in Enoch's Book of Secrets

MARUT

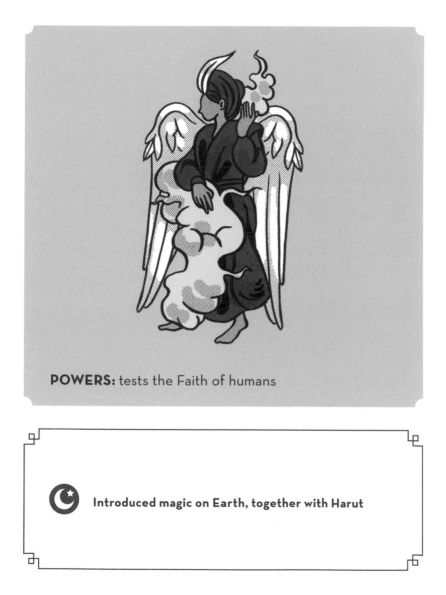

POWERS: tests the Faith of humans

Introduced magic on Earth, together with Harut

MATARIEL

POWERS: governs the rain

Angel of the Rain, according to the Book of Enoch

MEBAHEL

THE MEANING OF HIS NAME: "God Who Protects"

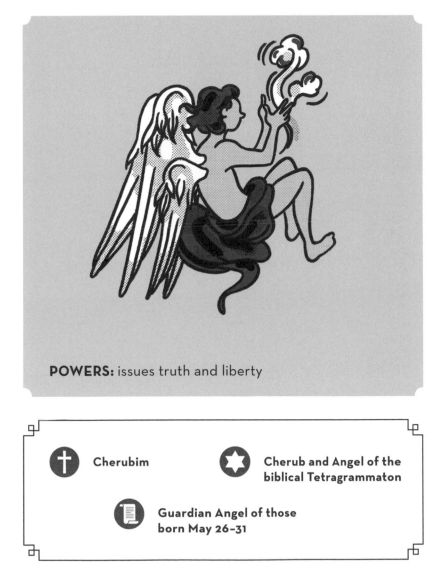

POWERS: issues truth and liberty

✝ Cherubim

✡ Cherub and Angel of the biblical Tetragrammaton

📜 Guardian Angel of those born May 26–31

MEBAHIAH

THE MEANING OF HIS NAME: "Eternal God"

POWERS: bestows intellectual lucidity

✝ **Principalities**

✡ **Principality and Angel of the biblical Tetragrammaton**

📜 **Guardian Angel of those born December 22–26**

MEHIEL

THE MEANING OF HIS NAME: "God Who Gives Life to All Things"

POWERS: bestows passion for life

✝ **Archangels**

✡ **Archangel and Angel of the biblical Tetragrammaton**

📜 **Guardian Angel of those born February 5–9**

MELAHEL

THE MEANING OF HIS NAME: "God Who Delivers from All Ills"

POWERS: heals psychophysical ills

✝ Thrones

✡ Throne and Angel of the biblical Tetragrammaton

📜 Guardian Angel of those born July 12–16

MELIOTH

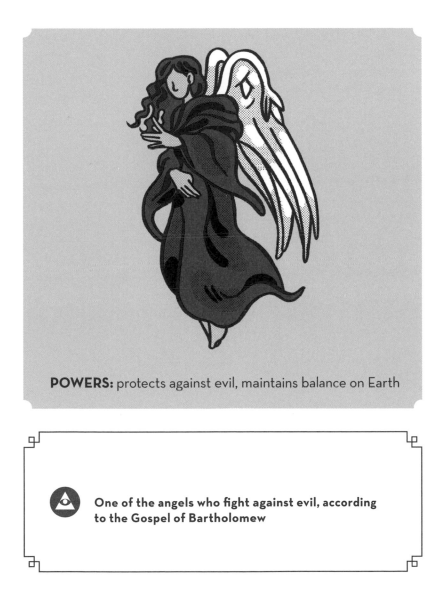

POWERS: protects against evil, maintains balance on Earth

> One of the angels who fight against evil, according to the Gospel of Bartholomew

MENADEL

THE MEANING OF HIS NAME: "Adorable God"

POWERS: protects workers, helps in issues regarding work

† Powers

★ Power and Angel of the biblical Tetragrammaton

📜 Guardian Angel of those born September 18-23

MERMEOTH

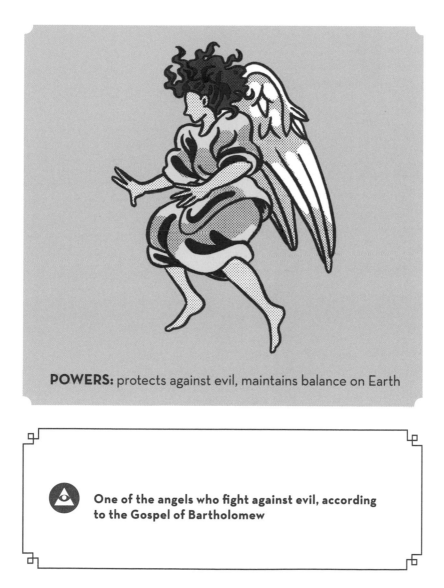

POWERS: protects against evil, maintains balance on Earth

One of the angels who fight against evil, according to the Gospel of Bartholomew

MIHAEL

THE MEANING OF HIS NAME: "God, the Merciful Father"

POWERS: favors maternity, protects mothers-to-be

✝ Virtues

✡ Virtue and Angel of the biblical Tetragrammaton

📜 Guardian Angel of those born November 18–22

MIKAEL

THE MEANING OF HIS NAME: "Reflection of God"

POWERS: helps improve organization, brings order to life and deeds

Virtues

Virtue and Angel of the biblical Tetragrammaton

Guardian Angel of those born October 19-23

MITZRAEL

THE MEANING OF HIS NAME: "God Who Aids theOppressed"

POWERS: helps forgive wrongdoings endured, consolidates relationships

✝ Archangels

✡ Archangel and Angel of the biblical Tetragrammaton

📜 Guardian Angel of those born January 16–20

MUMIAH

THE MEANING OF HIS NAME: "End of the Universe"

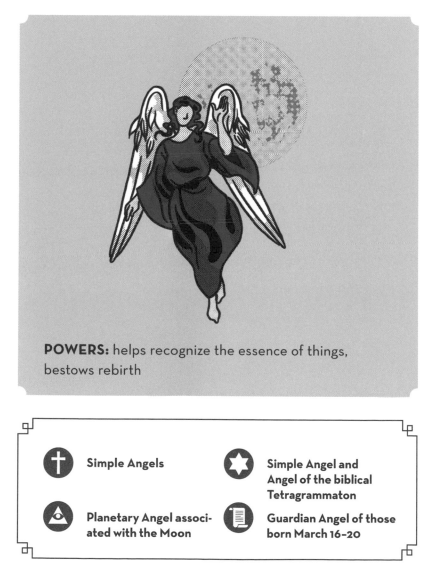

POWERS: helps recognize the essence of things, bestows rebirth

✝ Simple Angels

✡ Simple Angel and Angel of the biblical Tetragrammaton

△ Planetary Angel associated with the Moon

📜 Guardian Angel of those born March 16–20

MUNKAR

POWERS: administers divine justice judging the deeds of the deceased

Angel who punishes sinners after death

MURIEL

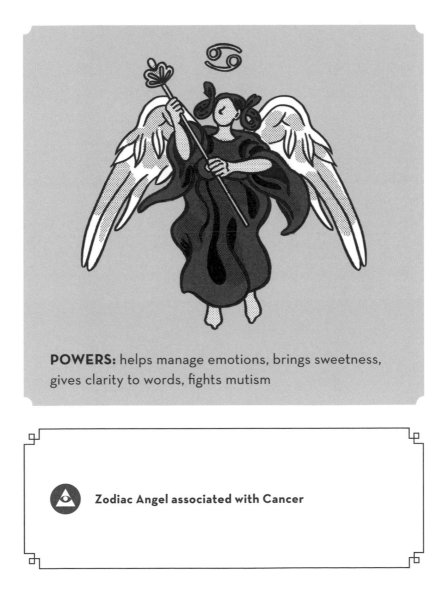

POWERS: helps manage emotions, brings sweetness, gives clarity to words, fights mutism

Zodiac Angel associated with Cancer

NAKIR

POWERS: administers divine justice judging the deeds of the deceased

Angel who punishes sinners after death

NANAEL

THE MEANING OF HIS NAME: "God Who Humbles the Proud"

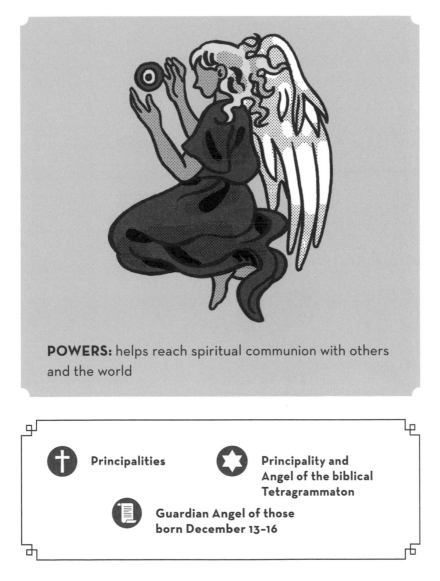

POWERS: helps reach spiritual communion with others and the world

✝ **Principalities**

✡ **Principality and Angel of the biblical Tetragrammaton**

📜 **Guardian Angel of those born December 13–16**

NATHANIEL

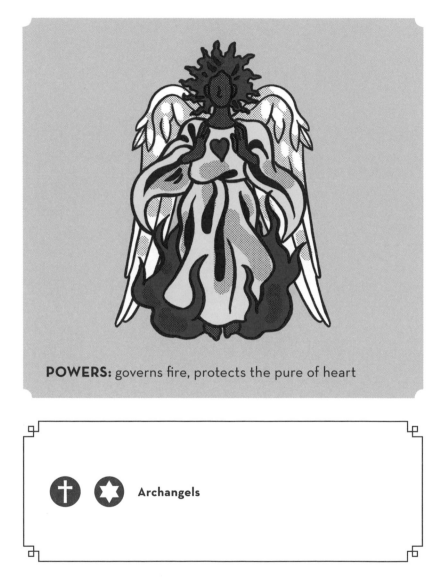

POWERS: governs fire, protects the pure of heart

<div>✝ ✡ **Archangels**</div>

NAUTHA

POWERS: governs the southwest wind

> Angel of the wind with a rod of snow to cool the air and keep the Earth from burning, described in the Gospel of Bartholomew

NECIEL

POWERS: stimulates intuition and new ideas

 Angel of the Moon

NEFONOS

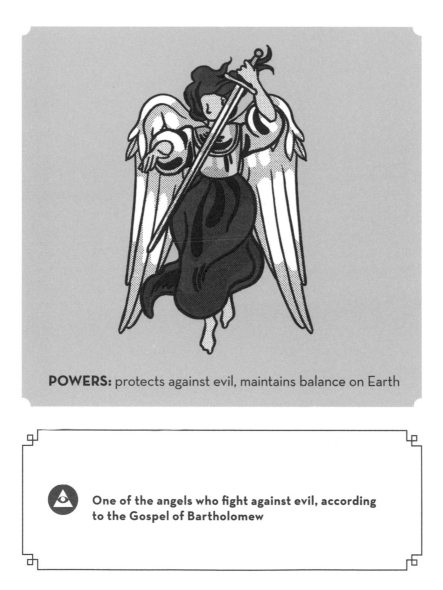

POWERS: protects against evil, maintains balance on Earth

One of the angels who fight against evil, according to the Gospel of Bartholomew

NELCHAEL

THE MEANING OF HIS NAME: "One and only God"

POWERS: protects those who teach, bestows knowledge

✝ **Thrones**

✡ **Throne and Angel of the biblical Tetragrammaton**

📜 **Guardian Angel of those born July 2–6**

NEMAMIAH

THE MEANING OF HIS NAME: "Admirable God"

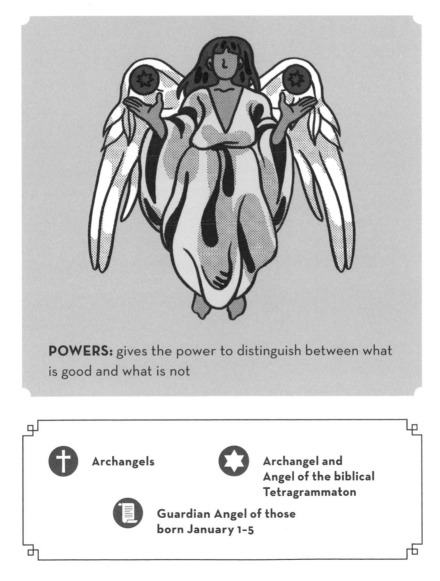

POWERS: gives the power to distinguish between what is good and what is not

✝ Archangels

✡ Archangel and Angel of the biblical Tetragrammaton

📜 Guardian Angel of those born January 1–5

NITHAEL

THE MEANING OF HIS NAME: "King of the Heavens"

POWERS: helps evaluate what will be left as a legacy after death

✝ Principalities

✡ Principality and Angel of the biblical Tetragrammaton

📜 Guardian Angel of those born December 17–21

NITHAHIAH

THE MEANING OF HIS NAME: "God Who Bestows Wisdom"

POWERS: bestows serenity

✝ Dominions

✡ Dominion and Angel of the biblical Tetragrammaton

📜 Guardian Angel of those born July 23–27

OERTHA

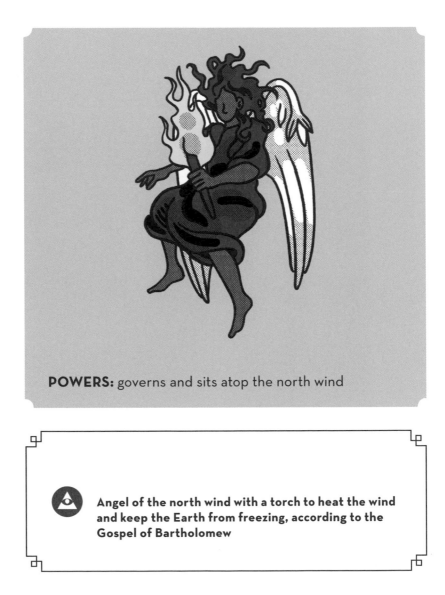

POWERS: governs and sits atop the north wind

Angel of the north wind with a torch to heat the wind and keep the Earth from freezing, according to the Gospel of Bartholomew

OFANIEL

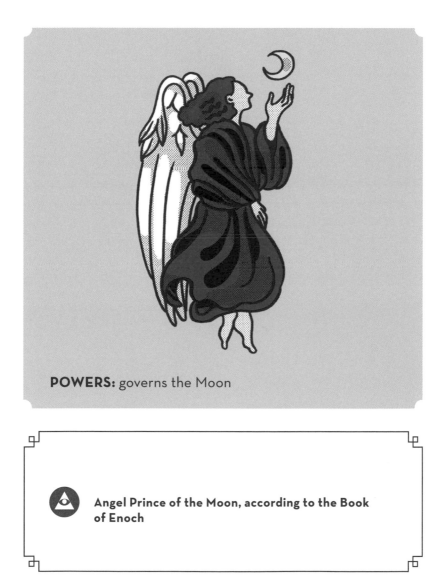

POWERS: governs the Moon

Angel Prince of the Moon, according to the Book of Enoch

OMAEL

THE MEANING OF HIS NAME: "Patient God"

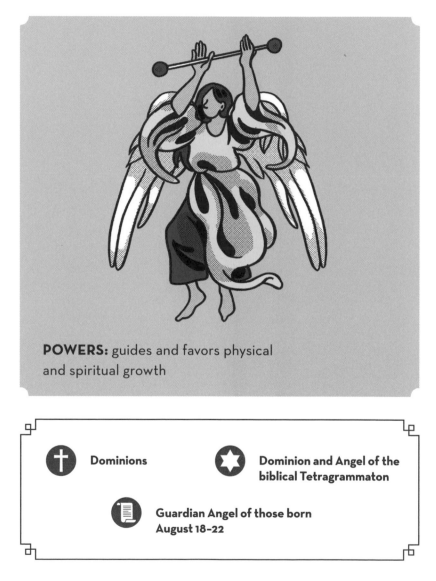

POWERS: guides and favors physical and spiritual growth

✝ **Dominions**

✡ **Dominion and Angel of the biblical Tetragrammaton**

📜 **Guardian Angel of those born August 18–22**

ONOMATAHT

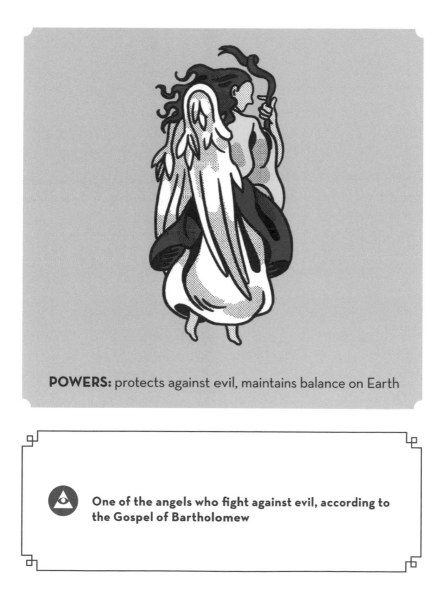

POWERS: protects against evil, maintains balance on Earth

One of the angels who fight against evil, according to the Gospel of Bartholomew

OROUEL

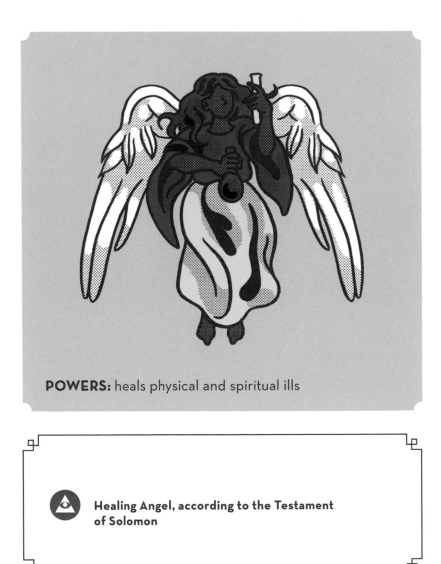

POWERS: heals physical and spiritual ills

Healing Angel, according to the Testament of Solomon

PAHALIAH

THE MEANING OF HIS NAME: "God the Redeemer"

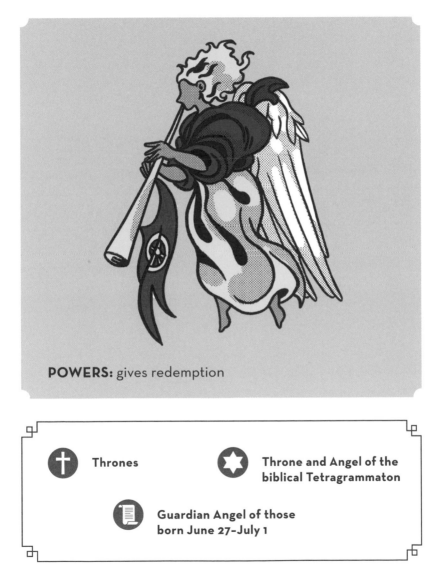

POWERS: gives redemption

✝ Thrones

✡ Throne and Angel of the biblical Tetragrammaton

📜 Guardian Angel of those born June 27–July 1

PHOUNEBIEL

POWERS: heals physical and spiritual ills

Healing Angel, according to the Testament of Solomon

POYEL

THE MEANING OF HIS NAME: "God Who Upholds the Universe"

POWERS: discover one's talents, bestows the virtue of modesty, brings good fortune

Principalities

Principality and Angel of the biblical Tetragrammaton

Guardian Angel of those born December 27–31

RAAMIEL

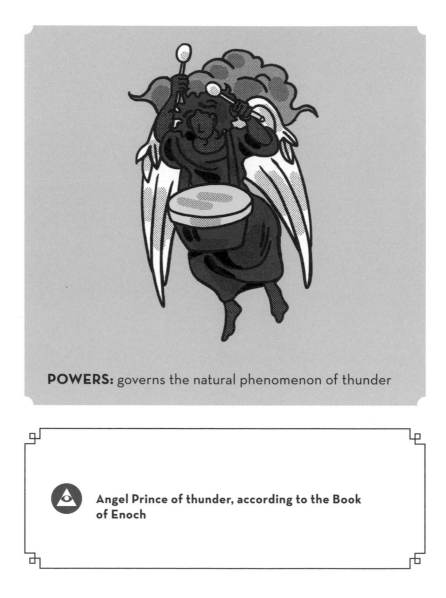

POWERS: governs the natural phenomenon of thunder

Angel Prince of thunder, according to the Book of Enoch

RAAZIEL

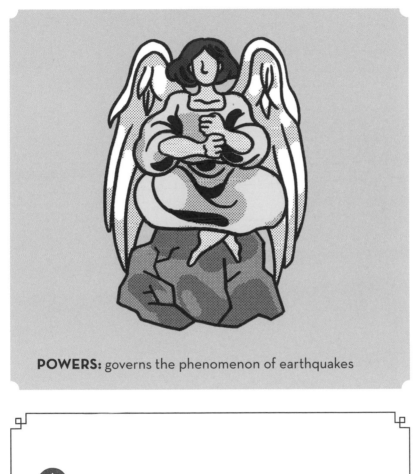

POWERS: governs the phenomenon of earthquakes

Angel Prince of thunder, according to the Book of Enoch

RAGUEL

THE MEANING OF HIS NAME: "Knight of the Wind"

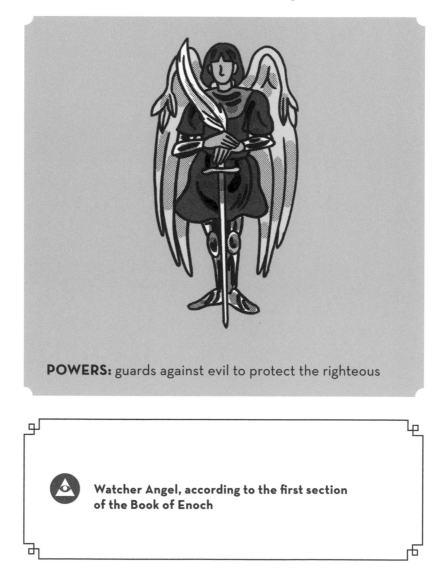

POWERS: guards against evil to protect the righteous

Watcher Angel, according to the first section of the Book of Enoch

RAIOUOTH

POWERS: heals physical and spiritual ills

Healing Angel, according to the Testament of Solomon

RAMUEL

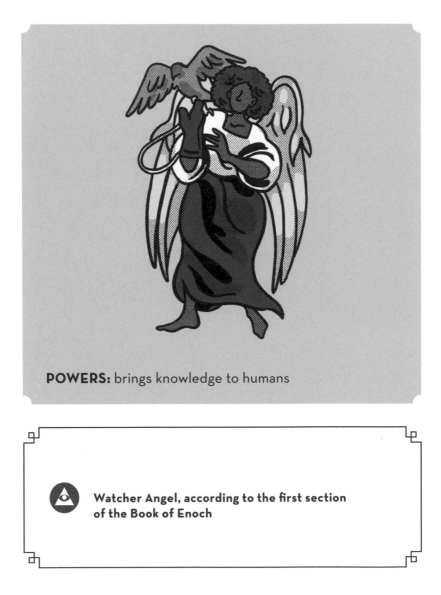

POWERS: brings knowledge to humans

Watcher Angel, according to the first section of the Book of Enoch

RARIDERIS

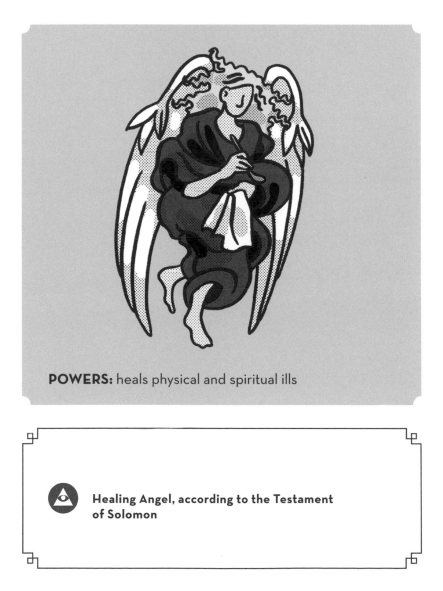

POWERS: heals physical and spiritual ills

Healing Angel, according to the Testament of Solomon

RASUIL

POWERS: protects and guides humans along their
spiritual path, instills wisdom

One of the two angels who took Enoch to heaven,
according to the Book of Enoch

RATHIEL

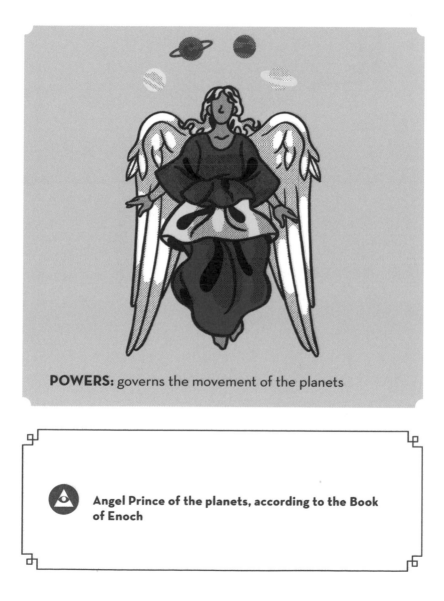

POWERS: governs the movement of the planets

🔺 **Angel Prince of the planets, according to the Book of Enoch**

REHAEL

THE MEANING OF HIS NAME: "God Who Accepts Sinners"

POWERS: conveys respect for life and for others

✝ Powers

✡ Power and Angel of the biblical Tetragrammaton

📜 Guardian Angel of those born October 4-8

REIYEL

THE MEANING OF HIS NAME: "God Who Is Ready to Help"

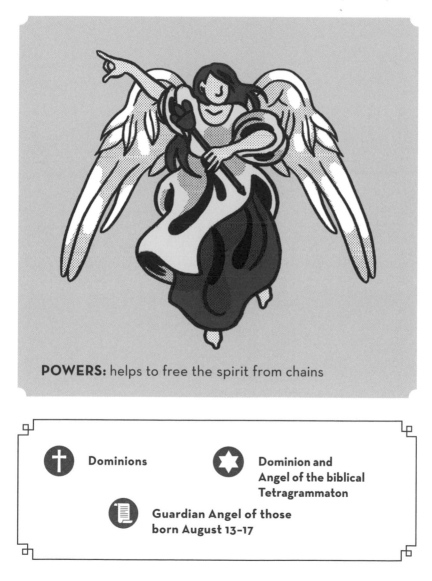

POWERS: helps to free the spirit from chains

✝ Dominions

✡ Dominion and Angel of the biblical Tetragrammaton

📜 Guardian Angel of those born August 13–17

REMIEL

POWERS: helps those who seek to elevate themselves

Watcher Angel, according to the first section
of the Book of Enoch

REQUIEL

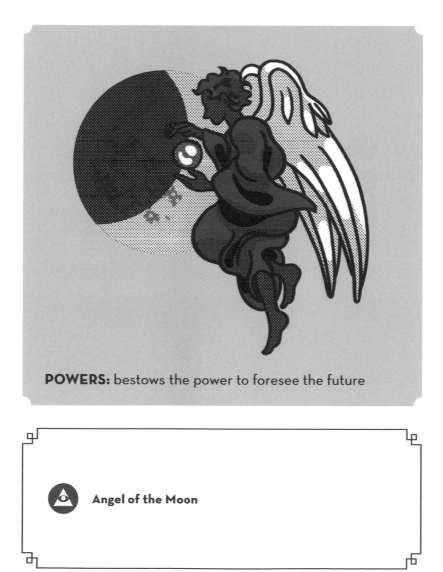

POWERS: bestows the power to foresee the future

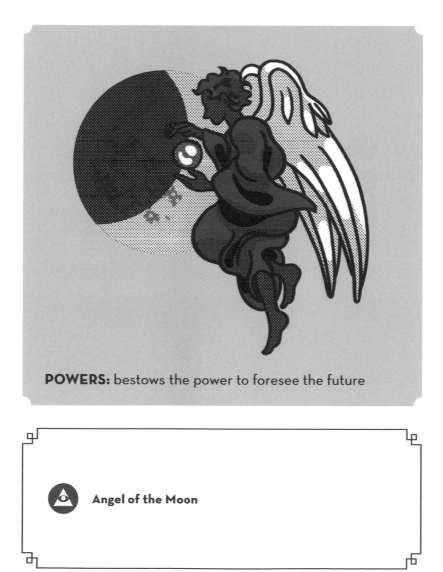 **Angel of the Moon**

RIDWAN

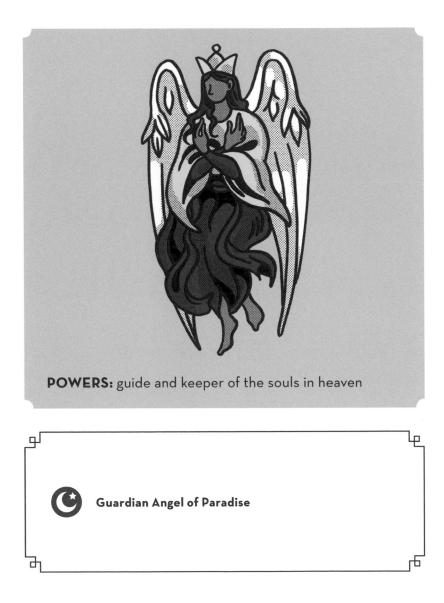

POWERS: guide and keeper of the souls in heaven

Guardian Angel of Paradise

RIZOEL

POWERS: heals physical and spiritual ills

Healing Angel, according to the Testament of Solomon

ROCHEL

THE MEANING OF HIS NAME: "All-Seeing God"

POWERS: clairvoyance, helps find lost objects

✝ **Simple Angels**

✡ **Simple Angel and Angel of the biblical Tetragrammaton**

🔺 **Planetary Angel associated with the Sun**

📜 **Guardian Angel of those born March 1–5**

RUBYAEL

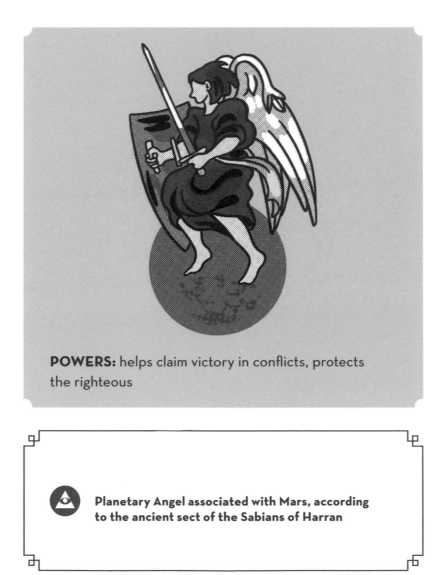

POWERS: helps claim victory in conflicts, protects the righteous

Planetary Angel associated with Mars, according to the ancient sect of the Sabians of Harran

RUFIYAEL

POWERS: helps attain material and spiritual well-being

Planetary Angel associated with Jupiter, according to the ancient sect of the Sabians of Harran

RUTHIEL

POWERS: governs the winds

Angel Prince of the wind, according to the Book of Enoch

SABAEL

POWERS: heals physical and spiritual ills

Healing Angel, according to the Testament of Solomon

SACHIEL

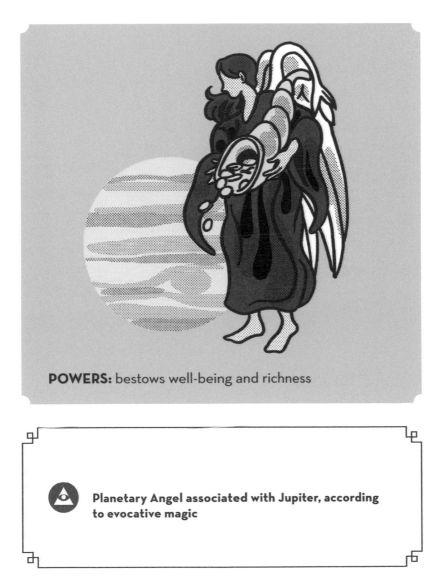

POWERS: bestows well-being and richness

Planetary Angel associated with Jupiter, according to evocative magic

SALGIEL

POWERS: oversees the natural phenomenon of snow

Angel Prince of the snow, according to the Book of Enoch

SAMAEL

POWERS: confers the strength to fight injustices, helps win battles

Planetary Angel associated with Mars, according to evocative magic

SAMS

POWERS: illuminates the mind and the path

Planetary Angel associated with the Sun, according to the ancient sect of the Sabians of Harran

SAMSAWEEL

POWERS: brings knowledge to humans

Watcher Angel, according to the first section
of the Book of Enoch

SAMZIEL

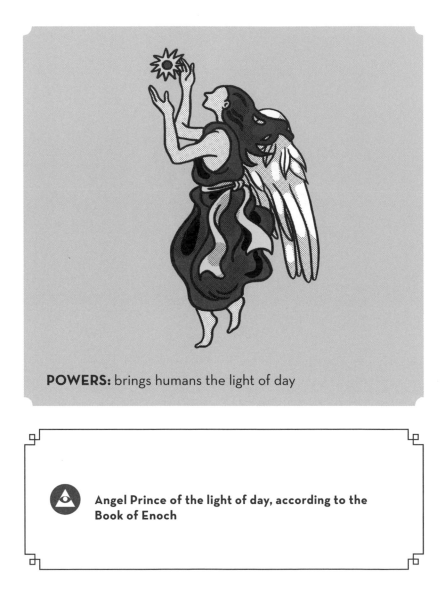

POWERS: brings humans the light of day

Angel Prince of the light of day, according to the Book of Enoch

SARCAEL

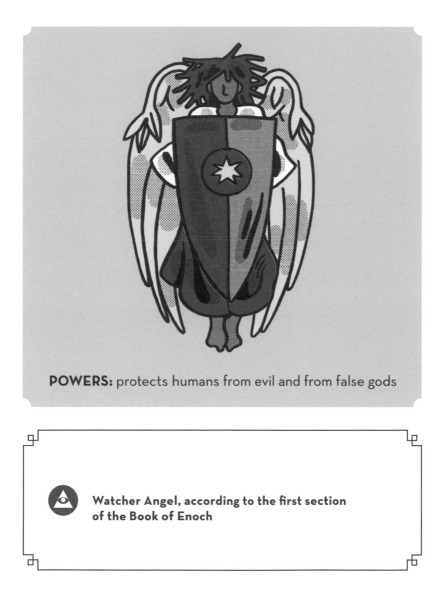

POWERS: protects humans from evil and from false gods

Watcher Angel, according to the first section of the Book of Enoch

SARTAEL

POWERS: one of the two hundred angels sent to Earth to instruct humans

Watcher Angel, according to the first section of the Book of Enoch

SATANAEL

THE MEANING OF HIS NAME: "God's Messenger"
(later called Satan)

POWERS: tempts humans and forces them to choose
between good and evil

SCALTIEL

THE MEANING OF HIS NAME: "The Word of God"

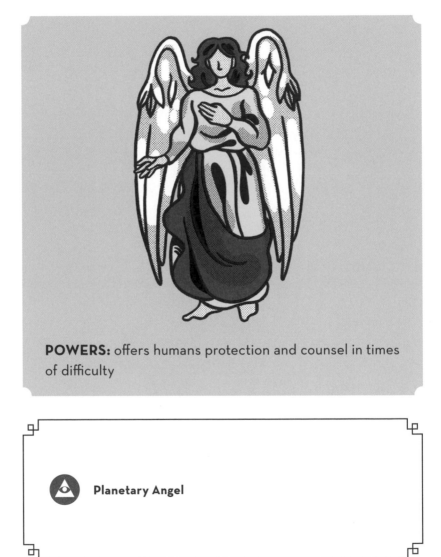

POWERS: offers humans protection and counsel in times of difficulty

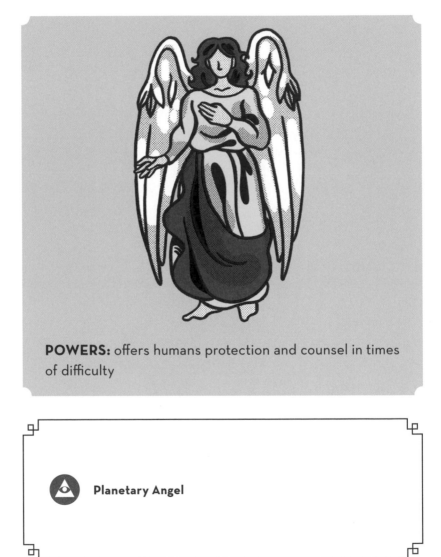 **Planetary Angel**

SEHALIAH

THE MEANING OF HIS NAME: "The Driving Force of All Things"

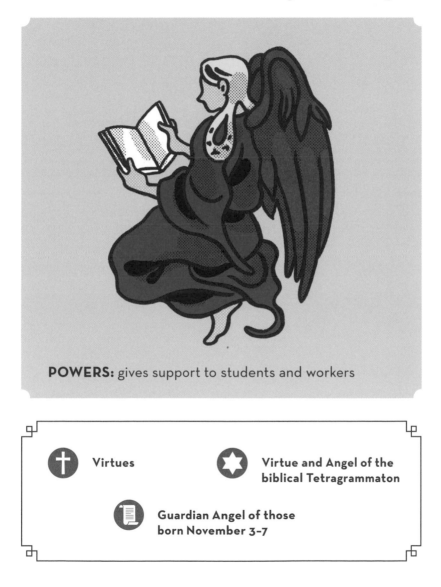

POWERS: gives support to students and workers

✝ **Virtues**

✡ **Virtue and Angel of the biblical Tetragrammaton**

📜 **Guardian Angel of those born November 3–7**

SEHEIAH

THE MEANING OF HIS NAME: "God Who Heals Ills"

POWERS: bestows long life

✝ Dominions

✡ Dominion and
Angel of the biblical
Tetragrammaton

📄 Guardian Angel of those
born August 7-12

SEHELIEL

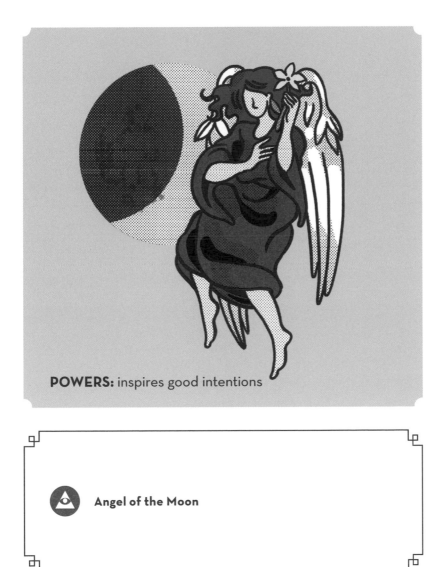

POWERS: inspires good intentions

Angel of the Moon

SEMEIL

POWERS: protects and guides humans on their spiritual path, instills wisdom

With Rasuil, one of the two angels who took Enoch to heaven, according to Enoch's Book of Secrets

SEMEYAZA

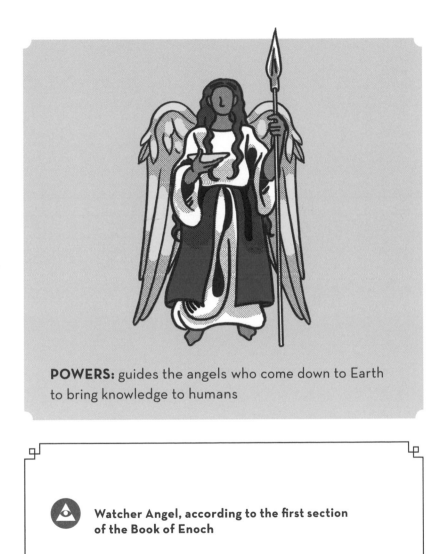

POWERS: guides the angels who come down to Earth to bring knowledge to humans

Watcher Angel, according to the first section of the Book of Enoch

SITAEL

THE MEANING OF HIS NAME: "God, the Hope of Every Creature"

POWERS: encourages good deeds

† Seraphim

✡ Seraph and Angel of the biblical Tetragrammaton

📜 Guardian Angel of those born March 31–April 4

SURAQUYAL

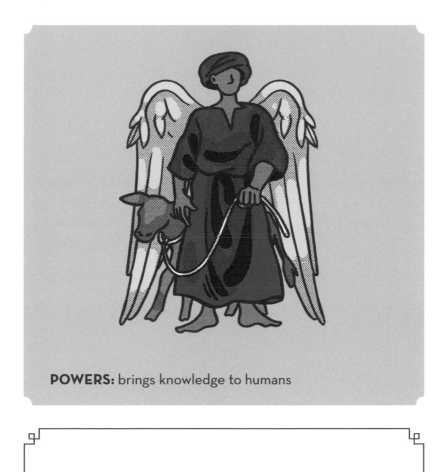

POWERS: brings knowledge to humans

Watcher Angel, according to the first section of the Book of Enoch

SURIEL

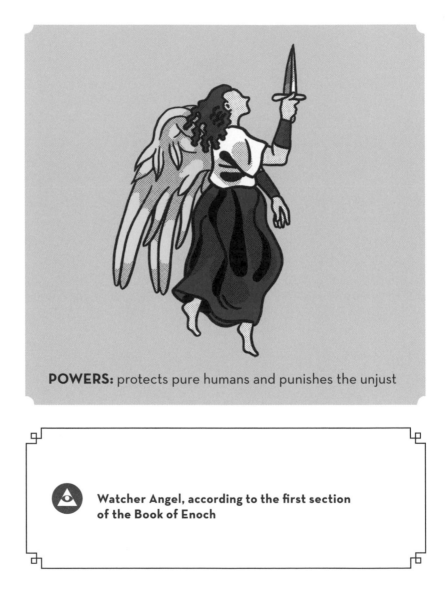

POWERS: protects pure humans and punishes the unjust

Watcher Angel, according to the first section of the Book of Enoch

SYLIAEL

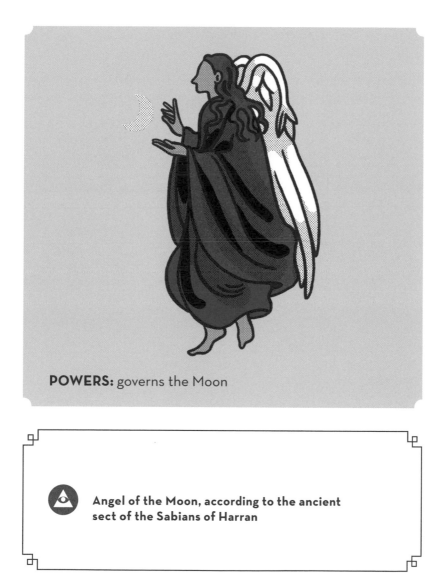

POWERS: governs the Moon

Angel of the Moon, according to the ancient sect of the Sabians of Harran

TAGRIEL

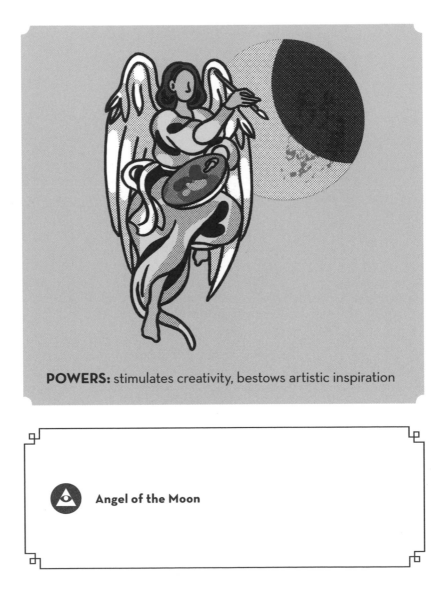

POWERS: stimulates creativity, bestows artistic inspiration

Angel of the Moon

TAKIEL

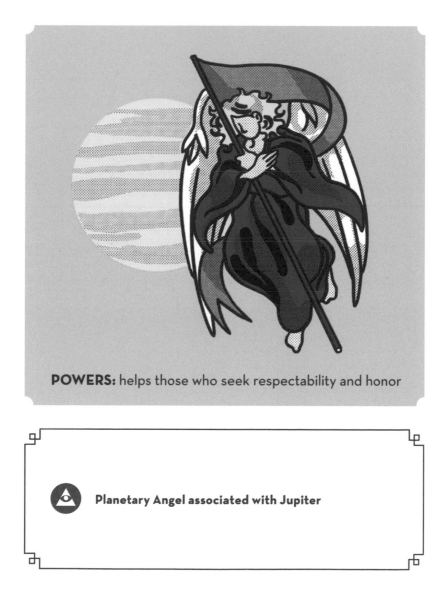

POWERS: helps those who seek respectability and honor

Planetary Angel associated with Jupiter

TAMIEL

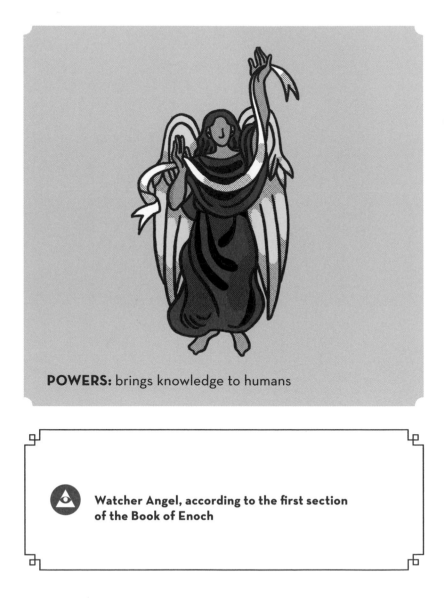

POWERS: brings knowledge to humans

Watcher Angel, according to the first section
of the Book of Enoch

TEMEL

POWERS: brings knowledge to humans

Watcher Angel, according to the first section
of the Book of Enoch

TUREL

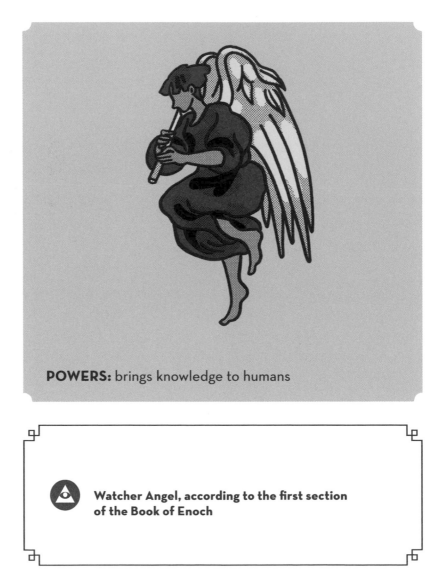

POWERS: brings knowledge to humans

Watcher Angel, according to the first section of the Book of Enoch

UMABEL

THE MEANING OF HIS NAME: "God above All Things"

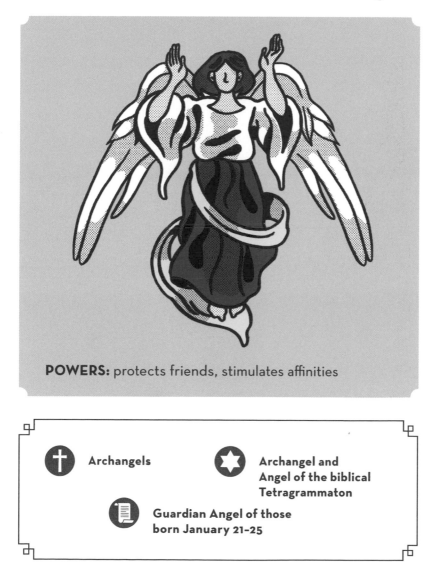

POWERS: protects friends, stimulates affinities

✝ **Archangels**

✦ **Archangel and Angel of the biblical Tetragrammaton**

📜 **Guardian Angel of those born January 21-25**

URAKIBARAMEL

POWERS: brings knowledge to humans

Watcher Angel, according to the first section
of the Book of Enoch

VASARIAH

THE MEANING OF HIS NAME: "Righteous God"

POWERS: facilitates generosity

✝ Dominions

✡ Dominion and
Angel of the biblical
Tetragrammaton

📜 Guardian Angel of those born
August 29–September 2

VEHUEL

THE MEANING OF HIS NAME: "God Who Exalts and Uplifts"

POWERS: guides along the path of spiritual elevation

✝ **Principalities**

✡ **Principality and Angel of the biblical Tetragrammaton**

📜 **Guardian Angel of those born November 23–27**

VEHUIAH

THE MEANING OF HIS NAME: "God Elevates above All Things"

POWERS: supports and encourages will

 Seraphim

Seraph and Angel of the biblical Tetragrammaton

Guardian Angel of those born March 21–25

VERCHIEL

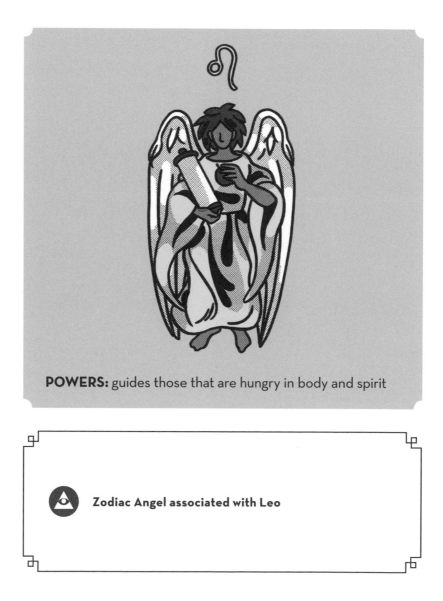

POWERS: guides those that are hungry in body and spirit

Zodiac Angel associated with Leo

VEREVEIL

POWERS: bestows knowledge

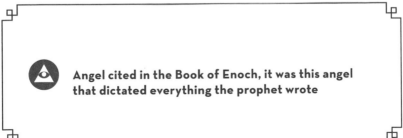

Angel cited in the Book of Enoch, it was this angel that dictated everything the prophet wrote

VEULIAH

THE MEANING OF HIS NAME: "Dominating King"

POWERS: helps achieve success

✝ **Virtues**

✡ **Virtue and Angel of the biblical Tetragrammaton**

📜 **Guardian Angel of those born October 24–28**

YEHUIAH

THE MEANING OF HIS NAME: "Omniscient God"

POWERS: brings harmony and understanding

✝ **Powers**

✡ **Power and Angel of the biblical Tetragrammaton**

📜 **Guardian Angel of those born September 3-7**

YEIALEL

THE MEANING OF HIS NAME: "God Who Satisfies Generations"

POWERS: bestows intelligence and mental strength

✝ Archangels

✡ Archangel and Angel of the biblical Tetragrammaton

📜 Guardian Angel of those born January 6–10

YEIAYEL

THE MEANING OF HIS NAME: "God's Right Hand"

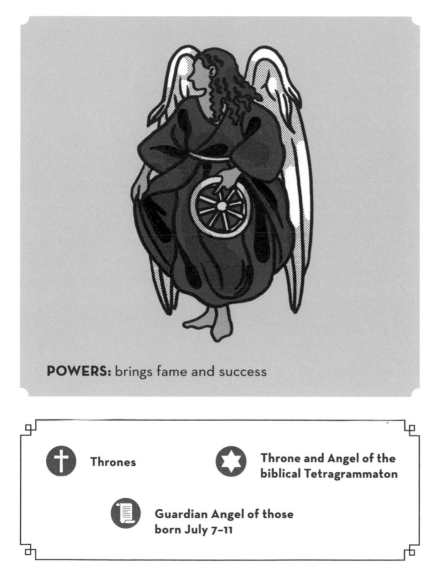

POWERS: brings fame and success

✝ Thrones

✡ Throne and Angel of the biblical Tetragrammaton

📜 Guardian Angel of those born July 7–11

YELAHIAH

THE MEANING OF HIS NAME: "Eternal God"

POWERS: protects members of the military

✝ Virtues

✡ Virtue and Angel of the biblical Tetragrammaton

📜 Guardian Angel of those born October 29–November 2

YERATEL

THE MEANING OF HIS NAME: "God Who Punishes the Blasphemers"

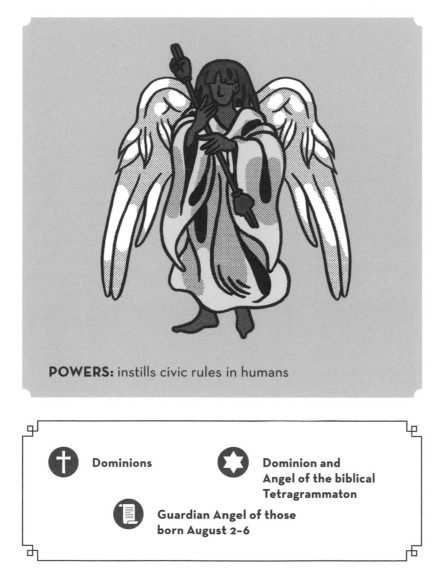

POWERS: instills civic rules in humans

✝ Dominions

✡ Dominion and Angel of the biblical Tetragrammaton

📜 Guardian Angel of those born August 2–6

YOMYAEL

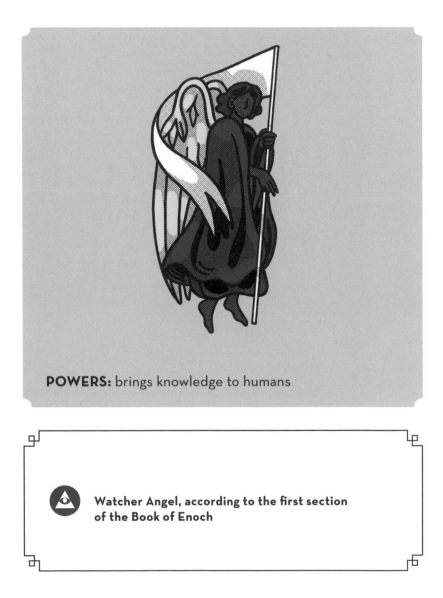

POWERS: brings knowledge to humans

Watcher Angel, according to the first section of the Book of Enoch

ZAAFIEL

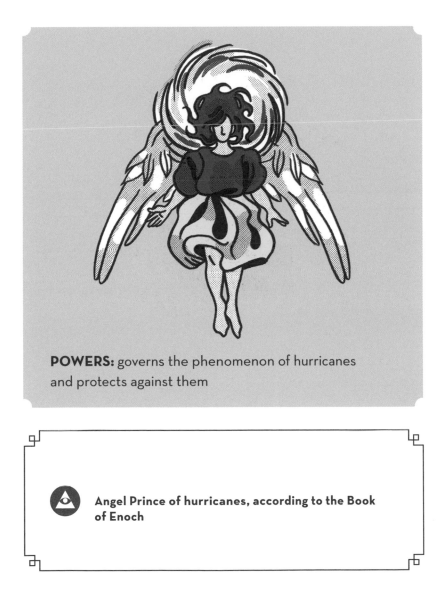

POWERS: governs the phenomenon of hurricanes and protects against them

Angel Prince of hurricanes, according to the Book of Enoch

ZAAMEEL

POWERS: governs the phenomenon of the storm and protects against it

Angel Prince of the storm, according to the Book of Enoch

ZAMAEL

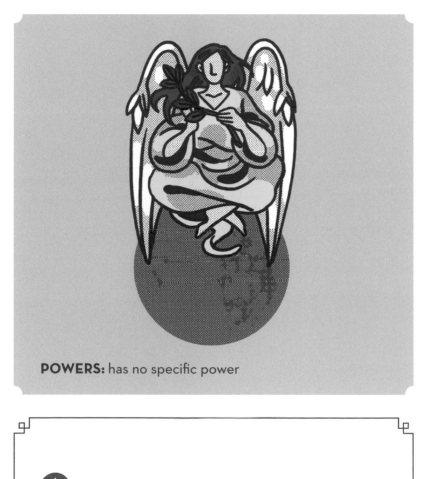

POWERS: has no specific power

 Planetary Angel associated with Mars

ZAQEBE

POWERS: brings knowledge to humans

Watcher Angel, according to the first section of the Book of Enoch

ZAWAEL

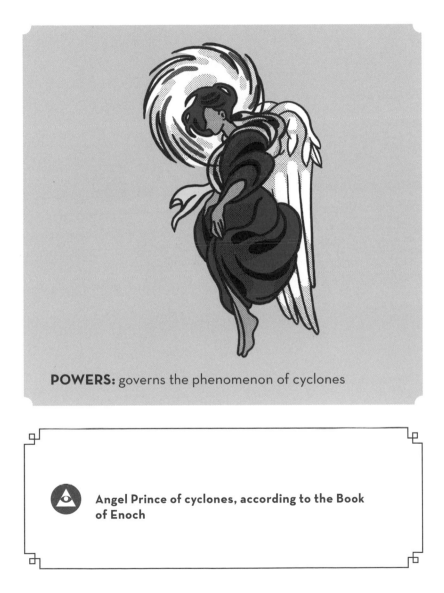

POWERS: governs the phenomenon of cyclones

Angel Prince of cyclones, according to the Book of Enoch

ZETACHIEL

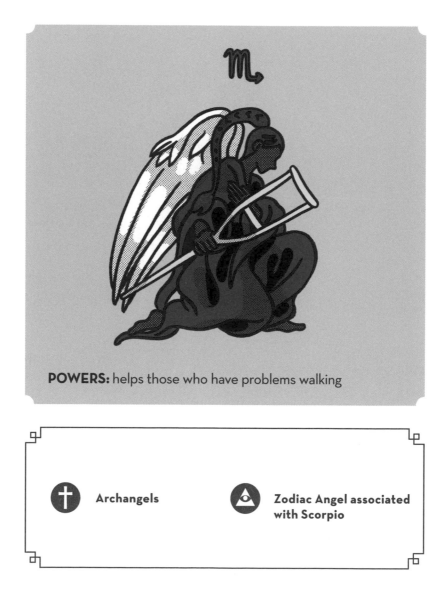

POWERS: helps those who have problems walking

✝ **Archangels**

△ **Zodiac Angel associated with Scorpio**

ZIQUIEL

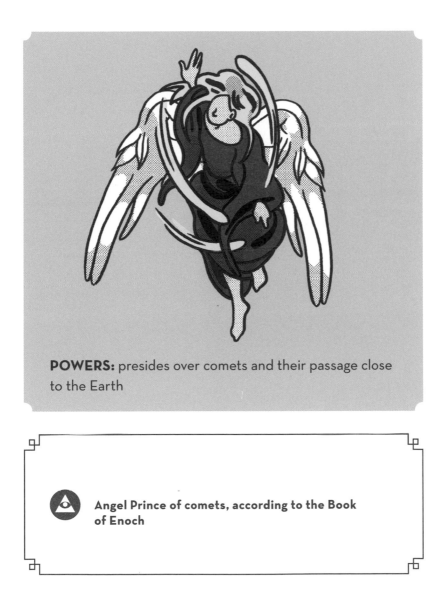

POWERS: presides over comets and their passage close to the Earth

Angel Prince of comets, according to the Book of Enoch

ZURIEL

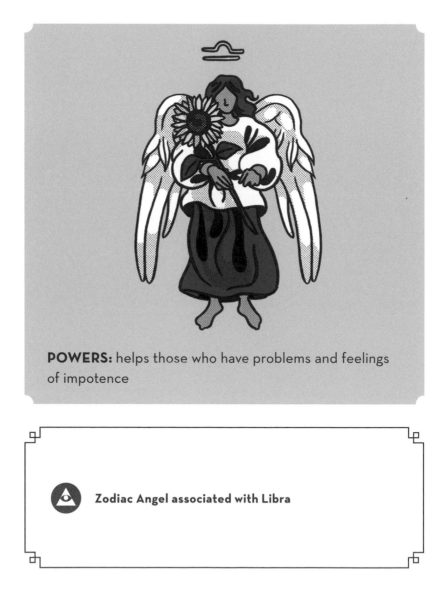

POWERS: helps those who have problems and feelings of impotence

Zodiac Angel associated with Libra

ZUTIEL

POWERS: has no specific power

Angel cited in the Book of Enoch in the section of the Watcher Angels, he took Enoch to the Garden of Eden

THE ANGELS
IN NUMBERS

72

GUARDIAN ANGELS
These are the angels closest to humans. They correspond to the angels in kabbalistic culture that were later recognized by the Catholic religion

11

ARCHANGELS
The nine archangels of the Hebrew Kabbalah (including the three Catholic and two Islamic archangels), Sandalphon, and Uriel

30

WATCHER ANGELS
From the two hundred mentioned in the Book of Watchers, the first section of the Book of Enoch

11

HEALING ANGELS
Described in the Testament of Solomon, they are no longer part of the official doctrine

28

ANGELS OF THE MOON
The rank of angels guided
by the archangel Gabriel

17

PLANETARY ANGELS
Associations with them
vary according
to religion

23

ANGELS ASSOCIATED WITH NATURAL PHENOMENA According to the Book of Enoch and to the Gospel of Bartholomew, as well as to ancient tales and traditional folklore

72

**ANGELS OF
THE BIBLICAL
TETRAGRAMMATON**

12

**ZODIAC
ANGELS**

BIBLIOGRAPHY

Armellini, F., *Sulla tua parola. Marzo-aprile 2021: Messalino. Santa Messa quotidiana e letture commentate per vivere la parola di Dio*, Shalom, 2020.

Cosentino, A. (introduction, translation, and notes, edited by), *Testamento di Salomone*, Città Nuova, 2013.

de Lubac, H., *Il pensiero religioso del padre Teilhard de Chardin*, Jaca Book, 2018.

Dionigi l'Areopagita, *Gerarchia celeste, Teologia mistica, Lettere*, translation, introduction, and notes by S. Lilla, Città Nuova, 1986.

Erbetta, M. (editor), *Gli apocrifi del Nuovo Testamento*, vol. I di III, Hoepli, 2000.

Garofalo, S. (editor), *La sacra Bibbia*, versione CEI, CEM, 1974.

Haziel, *Angeli, chi sono e a che cosa servono*, Anima edizioni, 2010.

Kefir, J., *La scienza dei sigilli del re Salomone*, Psiche 2, 2017.

Penna, A., *Gli angeli: Scoprirli, sentirli, incontrarli, pregarli*, De Vecchi, 2020.

Sacchi, P., *Gli apocrifi dell'Antico Testamento*, UTET, 2013.

Teilhard de Chardin, P., *Il fenomeno umano*, Queriniana, 2020.

ANGEMÌ RABIOLO

Angemì Rabiolo is a journalist, copywriter, and editor. He has a passion for art, theology, reading, philosophy, and comics. He is curious and eclectic, and if he could have a superpower, it would be teleportation.

IRIS BIASIO

Iris Biasio is an illustrator and cartoonist. She earned her degree in Graphic Arts and Engraving at the Venice Academy of Fine Arts. In 2016, she created and produced the editorial project *NeroVite*, which tells stories with words and drawings.

Design and editorial coordination
Balthazar Pagani

Editor
Caterina Grimaldi

Graphic design and editing
PEPE *nymi*

Vivida

Vivida™ is a trademark owned by White Star s.r.l.
www.vividabooks.com

This edition first published in 2022 by Red Wheel Books, an imprint of
Red Wheel/Weiser, LLC
With offices at
65 Parker Street, Suite 7
Newburyport, MA 01950
www.redwheelweiser.com

© 2021 White Star s.r.l.
Piazzale Luigi Cadorna, 6
20123 Milan, Italy
www.whitestar.it

Translation: Milan (translation: Cynthia Anne Koeppe;
layout: Lorenzo Sagripanti)
Editing: Phillip Gaskill

ISBN 978-1-59003-529-0

Library of Congress Cataloging-in-Publication Data available upon request

Printed in Poland
1 2 3 4 5 6 25 24 23 22 21